IMAGES
of America

HORSEHEADS

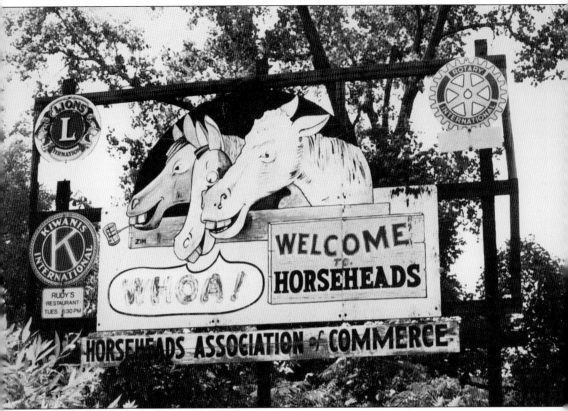

In 1779, near this spot, Gen. John Sullivan mercifully disposed of his packhorses, who were worn out by faithful service in the campaign against the Iroquois. The first white settlers entering the valley in 1789 found the bleached skulls and named the place Horseheads. (Courtesy of Joan O'Dell.)

ON THE COVER: Hanover Square is decorated for the festivities of the July 4, 1910, firemen's convention parade. The annual convention was held in Horseheads from the late 1890s into the 20th century. (Courtesy of the Horseheads Historical Society.)

IMAGES of America
HORSEHEADS

Marcia Tinker

Copyright © 2013 by Marcia Tinker
ISBN 978-0-7385-9910-6

Published by Arcadia Publishing
Charleston, South Carolina

Printed in the United States of America

Library of Congress Control Number: 2012951994

For all general information, please contact Arcadia Publishing:
Telephone 843-853-2070
Fax 843-853-0044
E-mail sales@arcadiapublishing.com
For customer service and orders:
Toll-Free 1-888-313-2665

Visit us on the Internet at www.arcadiapublishing.com

I dedicate this book to my grandfather, Harry E. Butters, who taught me the love for history, photography, and art. As a child, I thought every house had a darkroom, everyone volunteered at historical and art museums, and paint palettes belonged on the kitchen table.

CONTENTS

Acknowledgments		6
Introduction		7
1.	The Valley of the Horses' Heads	9
2.	Crossroads, Canals, and Railroads	13
3.	Hanover Square	23
4.	Industry and Commerce	43
5.	Schools, Churches, and Homes	67
6.	Social Life	91
7.	Horseheads People of Note	111
About the Horseheads Historical Museum		127

ACKNOWLEDGMENTS

This project has allowed me to see my hometown with new eyes. As I turn every corner, I am caused to explore what was there and what is there now. The richness of our heritage is not forgotten. Buildings and businesses may come and go, but the genuineness of the people remains. Horseheads will always be a wonderful town to live in.

Foremost, I would like to thank all of the people of Horseheads, whose encouragement and good wishes put me on the path to compile the information for Images of America: *Horseheads*. I could not have written this book without the support of the Horseheads Historical Society and the availability of its archives of information and photographs.

Richard Margeson, the president of the society, and historian Joan O'Dell provided many words of advice and a pile of photographs. Leah Cramer offered her wonderful collection of historical facts. Jean Quinn's collection of periodicals gave much insight to all that was written before. Susie Driscoll and Barb Tighe Skorcheski found family photographs to share with us. I will never forget reading all of Nadine Ferraioli's *Bygone Days* articles and the wealth of history and humor that they provided. Nadine, a longtime historian and president of the Horseheads Historical Society, also left in her passing many notes, clippings, and writings on the town and village. Paddy Bachman also left us literally boxes and boxes of information. It was fascinating to go through the folders that she had organized on just about anything that ever happened in the county.

Of course, most of all, I have to thank my mother, Joanne Tinker, and my husband, Pat Arndt, for putting up with me. Thanks Mom, for doing so much research and sorting. She reread every *Chemung Valley History Journal* in her collection—and she has them all. And Pat, thank you for your love and support and patience. Now, I might have time to bake you an apple pie.

Unless otherwise noted, all images in this book are from the archives of the Horseheads Historical Society.

Introduction

A 28-square-mile memorial unparalleled in American military history is the proud distinction that enshrines the town and village of Horseheads. It is the first and only town and village to be dedicated to the service of the American military horse. The horses passed through the area on a campaign for Gen. George Washington in the Revolutionary War. Gen. John Sullivan and his army were sent north through New York State to devastate the Six Nations of the Iroquois in 1779. On their return through the area, it was necessary to kill the worn-out military horses. As the Indians returned, they found the horses' skulls and arranged them along the trails.

About 10 years after this march, many soldiers returned as early pioneers, building homes along the same trails. John Breese was the first of these settlers to come to Horseheads. Many other Revolutionary soldiers joined Breese as a result of the Soldiers' Claim Act, which paid soldiers in land rather than in cash. Conkling, Sayre, Teal, and Carpenter were early pioneer families who claimed land in Horseheads. Ezra L'Hommedieu claimed 1,440 acres, which would become many early farms. Nathan Teal deeded 144 acres of his land to James Sayre for public burying grounds, which were later abandoned. The first two-room school was built there, followed by the Teal schoolhouse, which operated from 1850 to 1892. The plot, now known as Teal Park, is the home of Zim's Bandstand and a center of activity for the village.

Horseheads grew with the onset of the New York State Canal System. The Chemung Canal and Feeder Canal brought transportation, trading, and many more settlers. The Industrial Age and railroads increased the village once again. Horseheads became a hub for the railroads, with four train depots in its heyday. The town became known for its high-quality brick and for the Victorian delicacy of celery. Grain and lumber mills sprang up, and foundries manufactured products for the entire region.

Hanover Square, the intersection of five Indian trails, became the center of activity. It was a natural place to set up shops, homes, and early businesses. The Horseheads Building Association, a group of prominent businessmen organized in 1853, was responsible for developing the square into a popular center for meeting and exchanging goods. However, all of the grand wooden buildings were lost in the great fire of 1862. The association soon rebuilt the square in splendid brick buildings. The Colwell Hotel was rebuilt and then became the Trembly House. The grand hotel was surrounded by verandas and stood three stories tall. Later, in its prime, the hotel was owned by Rufus Platt and known as the Platt House, a well-known political gathering place. In 1904, the Platt House was the center of a fine ball celebrating the installation of electricity and water to the village.

Named the Valley of the Horses' Heads by the early settlers, the name was refined to the more polite Horseheads, and was incorporated as a village in 1837. Due to the significance the village played in the Chemung Canal system, the name was then changed to Fair Port, or Fairport. However, another village, in Monroe County, had also been named Fairport, causing Horseheads to regain its original name in 1845. In the mid-1880s, the name was once again changed, this

time to North Elmira. There was much dislike and controversy surrounding the name change. Rev. Thomas K. Beecher, in a letter to the editor of the *Elmira Advertiser*, denounces the idea of the new name. He writes, "The best names in the county are Chemung, Big Flats, Hendy Hollow and Horseheads. The cheap trick of Northing, Southing, and Centering an old name betrays intellectual feebleness, poverty of invention." In 1885, Dr. Robert Bush won a seat in the New York Assembly and became a champion of the old name. That same year, after assemblyman Jonus VanDuzer introduced a bill changing the name of Horseheads to North Elmira, the village voted, and Horseheads once again regained its name, by nine votes.

Horseheads is both a town and a village. On February 8, 1854, the Town of Horseheads was established to take over the Village of Horseheads from the Town of Elmira. In 1889, a two-story town hall and fire department was built on the corner of Main and John Streets. The town and village occupied the brick structure until the 1950s. In 1957, the town moved its offices to a new structure on South Avenue, its first permanent home since it was as established in 1854. The town has since moved to a complex on Wygant Road. In 1962, the village moved into a new village hall that was erected at the corner of Main and John Streets locations. The fire department also moved into new quarters, at 134 North Main Street, the site of the old canal tollhouse.

One
THE VALLEY OF THE HORSES' HEADS

Authorized by Congress in February 1779 and followed by the New York Legislature on March 13, 1779, the Sullivan-Clinton Expedition was organized to devastate the Indians of the Six Nations of the Iroquois and capture the British fortresses at Oswego and Niagara. Gen. John Sullivan and James Clinton were chosen by Gen. George Washington to command the troops for this portion of the War for Independence. Setting out from Easton, Pennsylvania, burdened with heavy equipment and 1,200 packhorses, the troops' journey was an arduous 450-mile trek through wilderness and swamps.

They arrived in the Chemung Valley in mid-August 1779. On August 31, after the Battle of Newtown, Sullivan's army swung north towards the lake country and the Genesee Valley. On the first night, it camped near Horseheads before entering the 12-mile Bear Swamp. Three weeks later, the tired and hungry soldiers, under immediate command of General Sullivan, retraced the same dismal route back. Exiting the swamp, the army was forced to kill, for humanitarian reasons, between 30 and 300 worn-out horses before returning to Fort Reed (Elmira). The horses' bodies were left along the banks of Newtown Creek. The diary of Maj. John Burrows includes the following: "Newtown, 24th September Friday: Marched at seven o'clock, the first four miles a very bad swamp, which after we got through we are obliged to kill more of our horses."

A few years later, the abundant horse skulls were arrayed along the trails by returning Iroquois. Reports claim that the skulls were a warning to the white man not to return to the area. As the first settlers arrived, the bleached white skulls were a sight to behold. These early pioneers built their homes in the region, naming it the Valley of the Horses' Heads.

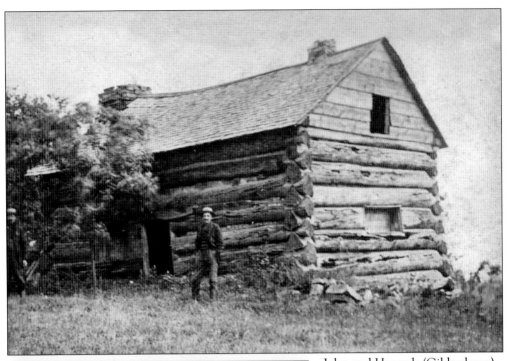

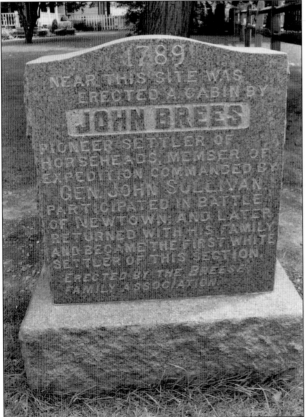

John and Hannah (Gildersleeve) Breese were the first pioneer settlers in the Valley of the Horses' Heads. In 1787, they and their eight children moved from Somerset County, New Jersey, to Chemung County. They lived in Newtown (Elmira) for two years, when their daughter Sarah became the first white child born in Chemung County. In 1789, they built this cabin in Horseheads.

In 1789, returning to the site the New Jersey troops of the Sullivan Expedition had used as a campground, the Breese family built the first log cabin in Horseheads. Later, this cabin became the first school in the Horseheads area. The Breese Family Association erected this granite marker at 911 South Main Street to commemorate the landmark. (Photograph by Marcia Tinker.)

Sarah Breese, seen here, married John Jackson, another early settler, from Brooklyn, who built the first two boats launched on the Chemung Canal: the *General Sullivan* and the *Lady Sullivan*.

The late-1800s Breese family reunion (pictured) was held at the home of Ulysses Breese, one of 99 grandchildren of John Breese. The owner of the Junction House at West Junction, Ulysses had this home built at the corner of Grand Central Avenue and Sayre Street when he became guardian for his two nieces.

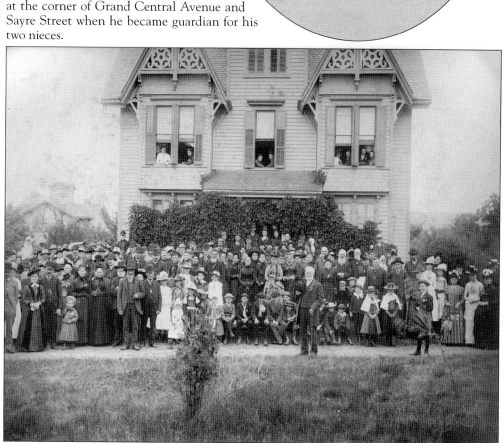

The September 1964 *Chemung County Historical Journal* reports, "The legend of the naming of Horseheads appears to have been verified on August 13, 1964, when a mass of horse skulls were uncovered by an excavation crew. Mrs. Lucille Rounds, town historian, said, that this discovery may be the first actual proof that General Sullivan's men had killed their horses after returning from the Genesee Valley." More than 100 jawbones, some with teeth, were discovered when a trench was dug in the freight yards of the Lehigh Valley Railroad. This once boggy location along Newtown Creek was also near the crossroads of what are now Ithaca and Franklin Streets. Rounds said, "Old-timers indicate that one place where the skulls were especially close together was the Hanover Square area, which would bear out the historical character of the Aug. 13 find."

Two

Crossroads, Canals, and Railroads

The 1830s brought the canal boom to New York State. The success of the Erie Canal inspired New York canals, including the Chemung Canal, which would connect the Chemung River northward to Seneca Lake. Horseheads was the junction point for the Feeder Canal, which left Horseheads and ran through Big Flats to Gibson in Corning. The tollhouse for both canals was located just north of Hanover Square. There, all boats were weighed before proceeding on. Horseheads became a center of commerce, and its importance was marked in May 1837, when the village was first incorporated as Fairport. In 1845, after many heated debates, the name Horseheads was restored.

The Chemung Canal enjoyed a prosperous 45-year lifetime. In 1854, at its peak, 270,978 tons of Pennsylvania coal, local lumber, and salt were shipped on the canal. Agrarian and industrial had become linked. From 1861 to 1865, tonnage remained strong during the Civil War. The Elmira Civil War depot required a large amount of supplies. As railroads grew, however, the canal business declined, and the Chemung Canal closed in winter 1878. In March 1880, canal bridges, locks, stone, timber, and iron were sold at auction.

Horseheads remained an industrial center and a crossroads as the railroads were built. Four depots were constructed within the Horseheads hub, serving the Pennsylvania; Delaware, Lackawanna & Western; Erie; and Lehigh Valley railroads. The canal was filled in many spots in order to lay the railroad tracks. The only train station left today is the Pennsylvania Railroad depot, which is now home to the Horseheads Historical Museum. It was built in 1866 after the previous depot, a rather shabby wooden one, burned in January 1864.

Horse-drawn trolleys became the first public transportation system in the county. On April 18, 1866, the New York Legislature authorized the construction of the Elmira-Horseheads Street Railway Company. The route ran from the Erie station in Elmira to the Junction Canal Bridge in Horseheads. In 1889, the Horseheads division switched from horses to steam dummy engines. In 1900, the line became the Elmira Water, Light & Railroad Company and ran on electric power. The coming of the automobile age ended trolley operations in 1930.

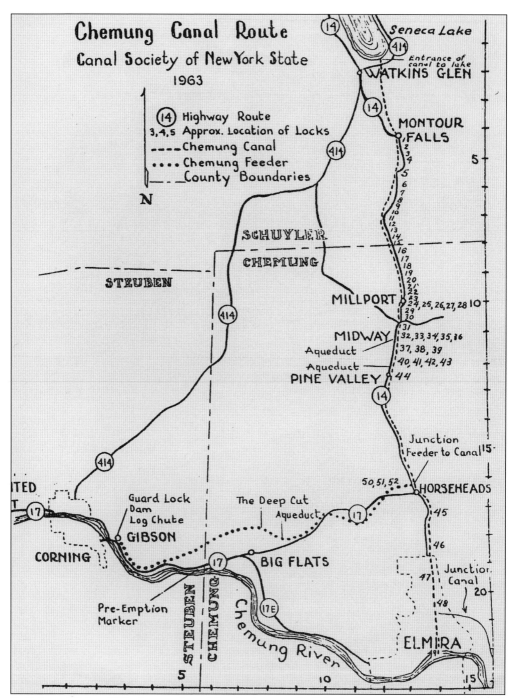

Built from 1830 to 1833, the canal was 23 miles long, with 49 locks. From Horseheads, it traveled north to the lumber town of Millport, then onward to Montour Falls and Seneca Lake. The trip took many days to complete, which meant many inns and stores sprang up along the canal route. (Courtesy of the Canal Society of New York.)

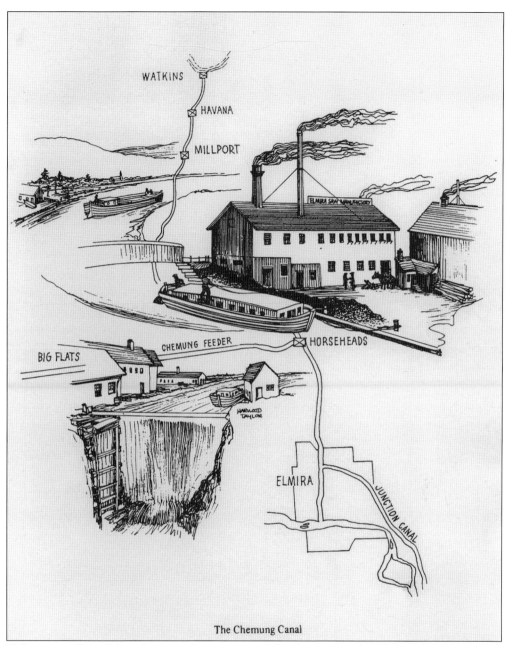

The Chemung Canal

Tolls were collected from boats at the junction of the Feeder Canal and the Chemung Canal. The Feeder Canal was not only for transportation, but also provided water for the main canal. From Horseheads, the Chemung Canal flowed directly north to Pine Valley, Millport, and Montour Falls.

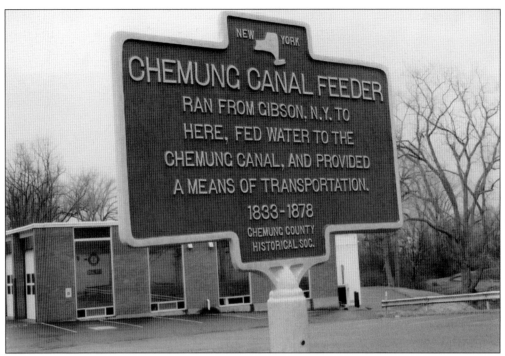

The junction of the Chemung Canal and the Feeder Canal can still be seen behind the fire department, at 134 North Main Street, the former site of the tollhouse. This New York State historical marker was unveiled in a 2009 ceremony.

The Lehigh Valley Railroad station was located between Ithaca Road and East Franklin Street in Horseheads. This 1910 photograph shows the two-story depot with recently installed electric poles.

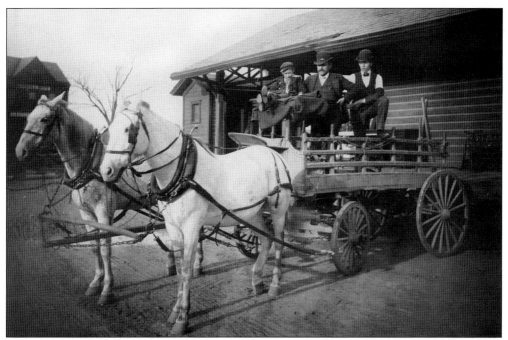

Tifft wagons like this one carried freight from Pennsylvania, Lehigh Valley, and later, Lackawanna trains from the late 1800s into the 1920s. Freight was delivered to businesses and stores in Horseheads and Elmira. Here, from left to right, a freight agent, Bela C. Tifft, and Jimmy Donahue are in front of the Lehigh Valley station. The Marshall Bros. and Deering businesses are across Ithaca Road. Tifft bought the first Pierce Arrow truck in Chemung County.

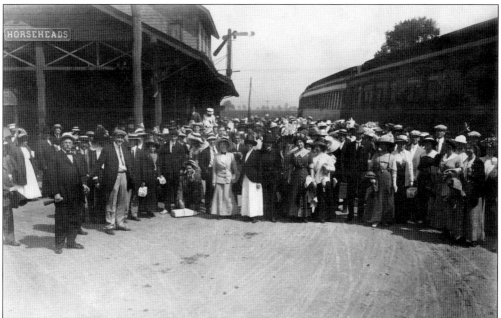

In July 1912, a group of summer travelers waits to board the train at the Lehigh Valley station. Sylvan Beach on Oneida Lake was a popular destination for a summer day-trip. Passenger business was good until after World War I.

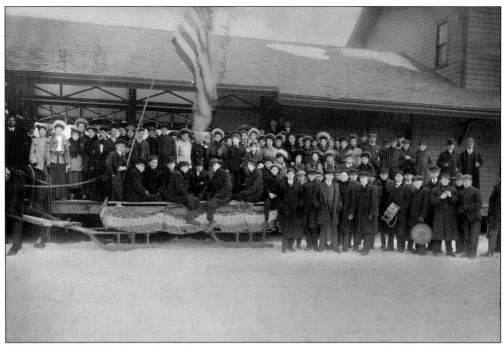

Horseheads High School students pose during the 1907–1908 school year at the Lehigh Valley station as they wait to go on a winter excursion. Note the bobsleds that were also headed for their destination.

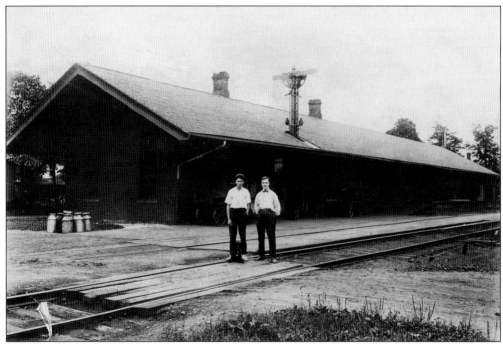

The Pennsylvania Railroad station was between John and Broad Streets and is now the home of the Horseheads Historical Society. Here, telegrapher Robert Donahue (right) and an unidentified man are standing at the John Street end of the depot around 1919.

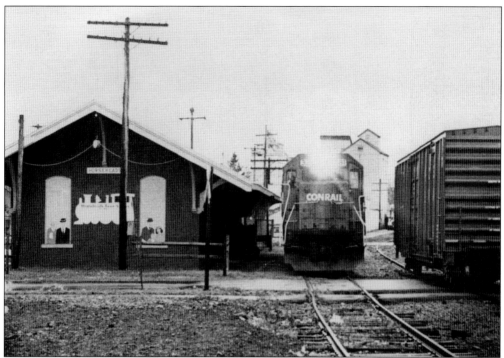

Conrail trains pass by the old "Pennsy" depot on John Street. Marshall's Feed Mill is in the background. The abandoned train station was used by the feed mill for warehousing and storage. Conrail trains would stop at the siding and unload grains into the old bays of the railroad station.

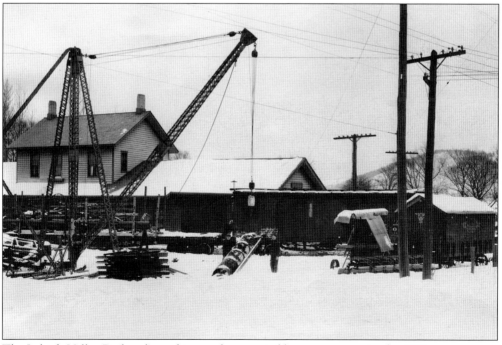

The Lehigh Valley Railroad's yard is seen here coated by a snowstorm in the 1920s.

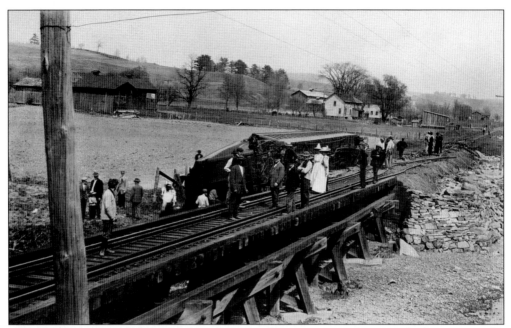

The railroad connecting Horseheads with Erin and Breesport, seen here, was built to service the lumber business of James and Joseph Rodbourne, who built a steam-powered lumber mill after the Civil War. The Utica, Ithaca & Elmira Railroad allowed them to reach markets for their lumber and wooden products, which included a patented potato crate.

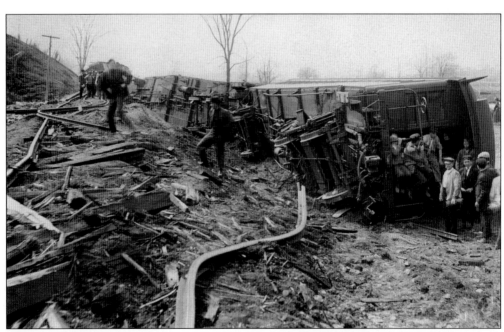

The Lehigh Valley Railroad took over the Utica, Ithaca & Elmira line. On May 8, 1911, this Lehigh Valley train derailed three miles from Horseheads near Bowman Hill Road in Breestown.

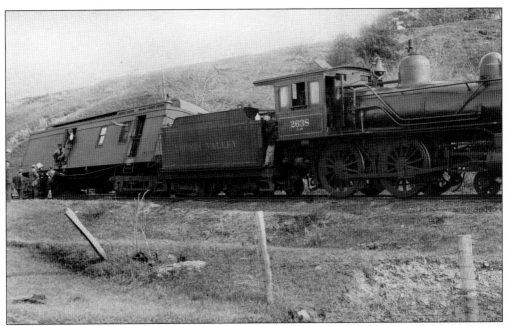

The railroad to Breesport ended in 1938. The Lehigh Valley Railroad removed the tracks, and employees of Bethlehem Steel dismantled the trestles between Park Station and Swartwood.

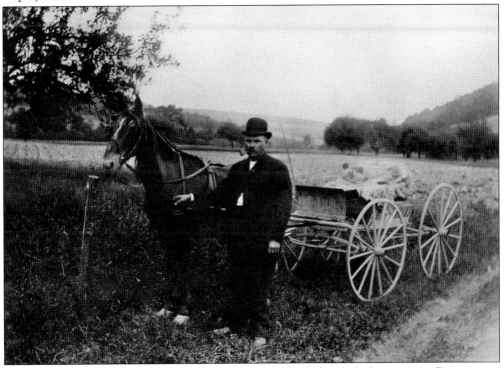

A June 24, 1938, Elmira newspaper headline reads "Man Who Rode first train to Breesport in 1872 to be passenger on last one, Saturday." Elias Wheaton of Breesport was the first and last person to ride the Lehigh Valley train between Elmira and Breesport. He was the sole passenger on the last train, on June 25, 1938, when he was 81 years old.

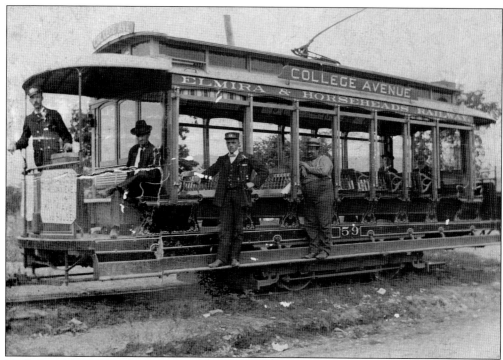

Trolley car No. 29 travels the College Avenue route of the Elmira & Horseheads Railway. The sides of the trolley were opened up on warm summer days, as seen here.

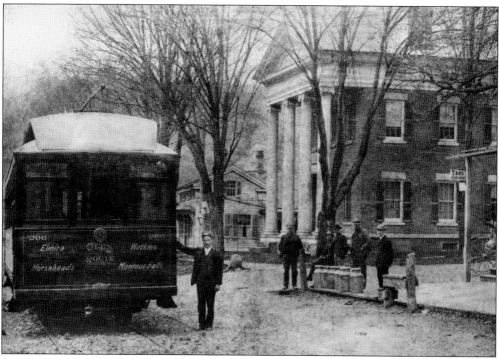

In this 1910 postcard of Main Street, Millport passengers and milk cans wait to board the trolley. The Glen Route carried passengers between Elmira, Horseheads, Montour Falls, and Watkins Glen.

Three
HANOVER SQUARE

Horseheads' iconic Hanover Square was built at the convergence of five centuries-old Indian trails, which are now North and South Main Streets, East and West Franklin Streets, and Ithaca Road.

No one knows exactly how or why Hanover Square got its name, but historian Nadine Ferraioli comes up with a very good explanation in one of her Bygone Days columns. Here is her story: "At the time between 1810 and the Canal Days, the 'Square' or hub of five roads was a place of meeting, a stopping over place and for 'handing over' of goods. Handover of lumber, produce, liquor, tobacco, hardware and brick all took place there. Goods were handed over for other goods and it began to be called Handover Square."

This center of the small village developed as commerce and industry grew with the Chemung Canal in the 1830s. The first hotel was operated by Vince Conkling at the corner of Main and Franklin Streets and was later known as the Hoffman House. The Colwell Hotel was built in 1828, and later became the Trembley House and then the well-known Platt House.

Horseheads lost its prominence as the county seat to Elmira in 1836; however, it retained the reputation as the political and social center. According to Thomas Byrne in *Chemung County, 1890–1975*: "In the rambling Platt House and in historic Pritchard Hall, above Hibbard's Hardware, politicians were made and unmade in many party conventions that often ended in near riot." Fire conventions took over Hanover Square in the late 1800s, festooning homes and businesses with fabulous buntings and banners.

The great fire of 1862 destroyed all the wooden buildings in the area of the square, but it was soon rebuilt. In 1873, the first fire apparatus was purchased and fire companies were formed, including the Pioneer No. 1, Acme No. 2, and Steamer No. 1. In 1889, the grand brick town hall and fire engine house was built on Main Street.

In 1871, tracks for the Elmira & Horseheads Railway were laid through Hanover Square. In 1964, officials considered creating a rotary traffic circle for the complicated intersection of the five streets, but opted not to. Still today, the famous Hanover Square intersection remains perplexing to both motorists and law enforcement officials.

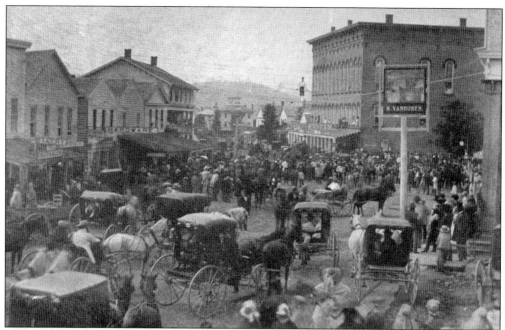

This rare photograph shows Hanover Square during a celebration around 1860. A tightrope walker crosses above Main Street. The Colwell House is the tallest building on the left, and the canal tollhouse is in the background. All the buildings in Hanover Square except for the Whitaker home burned in the great fire of 1862. The square was then rebuilt in brick by the newly formed Horseheads Building Association.

The Whitaker home, at 210 South Main Street, was the only building spared by the 1862 fire. Here, Jessie Whitaker (left) and an unidentified servant pose in front of the house in the late 1800s. The house is now a gift shop, located next to the village hall, which replaced the brick fire station and town hall in 1962.

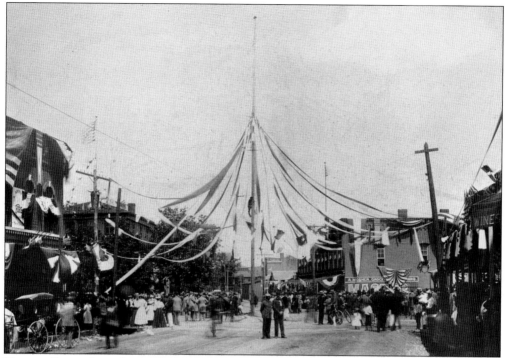

Hanover Square hosted many firemen's conventions, including the one seen here on July 15, 1896. Platt House is on the far left, the tracks for horse-drawn trolleys are in the center, the Judson coal yard is in the far distance, and the Mosher Grocery and Clothing Store is at the corner of Main Street and Ithaca Road.

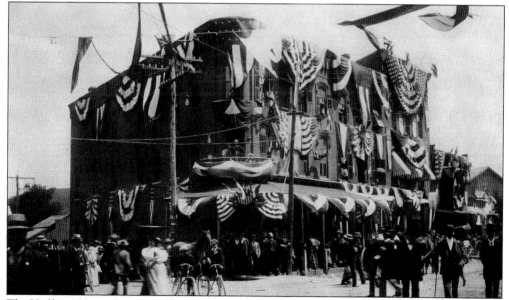

The Hoffman House Hotel, on the corner of Main and West Franklin Streets, is seen here festooned for the second annual firemen's tournament, convention, and parade, in 1896. Highlights of the convention included the hook-and-ladder race, the hose race, and the grand parade, led by grand marshal Dr. Robert Bush, the former speaker of the New York State Assembly.

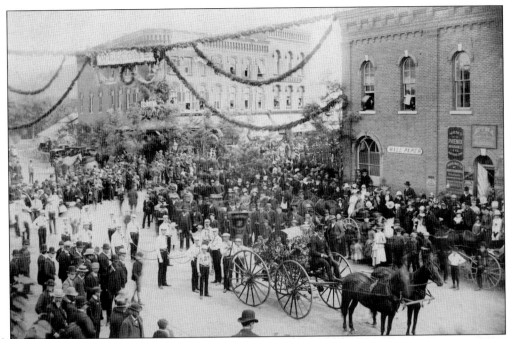

This July 4, 1910, firemen's parade turns at the northwest corner from Main Street onto West Franklin Street. Hanover Square continues to be the center of community festivities, including the celebration of Holly Days, St. Patrick's Day, and the Celery Festival, to name a few.

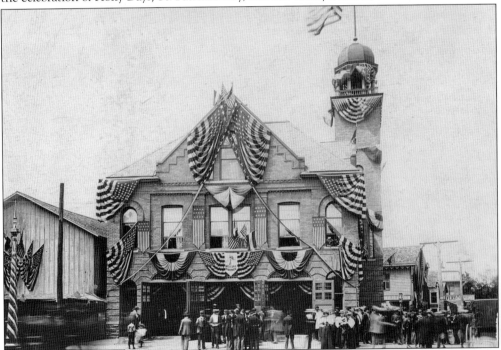

The Horseheads town hall and fire engine house was built in 1889 on the corner of John and South Main Streets. The fire bell in the tower is now located in front of the current village fire department. The businesses of the day are seen here on John Street.

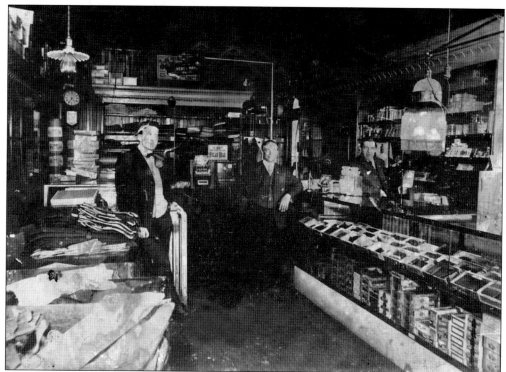

Henry Messing (left) and his brother-in-law Lauren Thomas (center) operated Thomas and Messing's dry goods store, seen here, on the corner of Main and West Franklin Streets. The store offered men's furnishings, newspapers, and cigars, and was also the meeting place for Horseheads men.

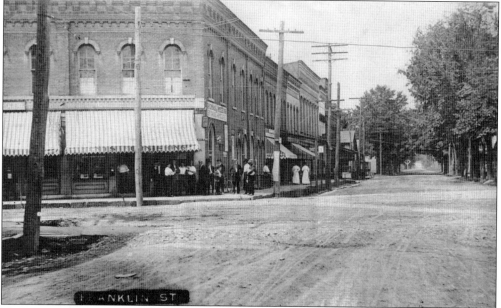

This view of Hanover Square looks west on Franklin Street around 1905 and shows the recently installed electric poles. Thomas and Messing's store is on the corner, and the Pennsylvania Railroad crossing is in the distance.

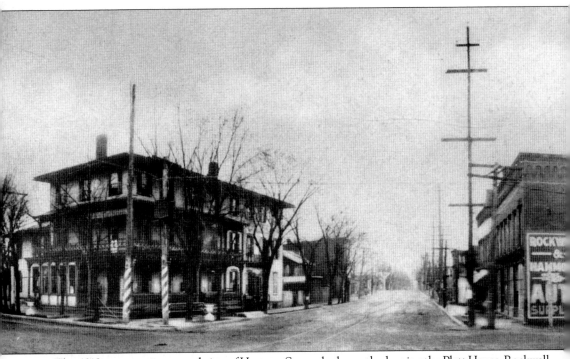
This 1910s panoramic postcard view of Hanover Square looks north, showing the Platt House, Rockwell

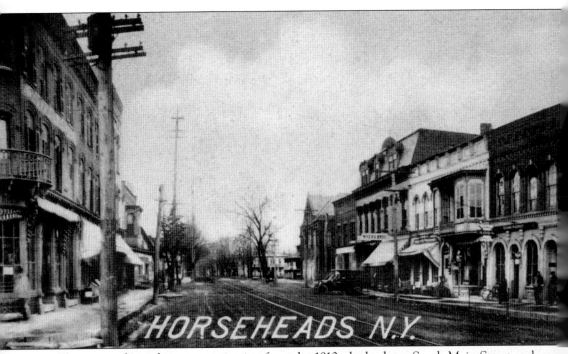
This postcard, another panoramic view from the 1910s, looks down South Main Street and up

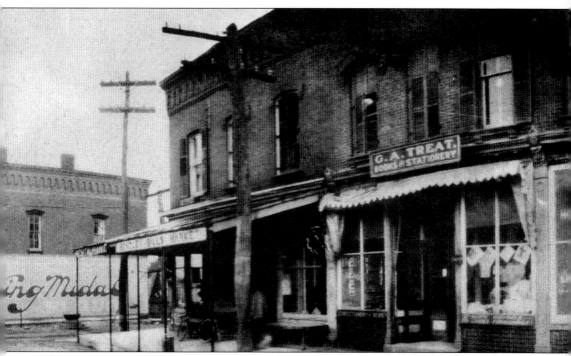

and Hammond's Auto Supplies, G.A. Treat Books and Stationery, and a market and restaurant.

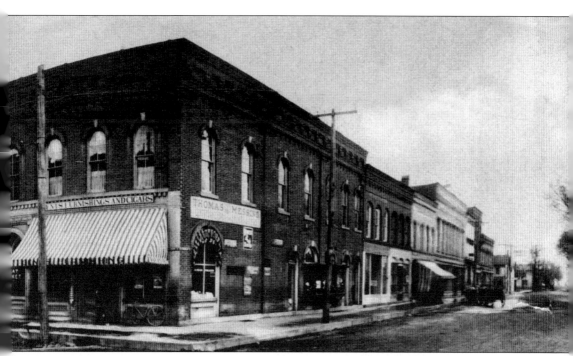

West Franklin Street. Postcard panoramas were very popular in the early 1900s.

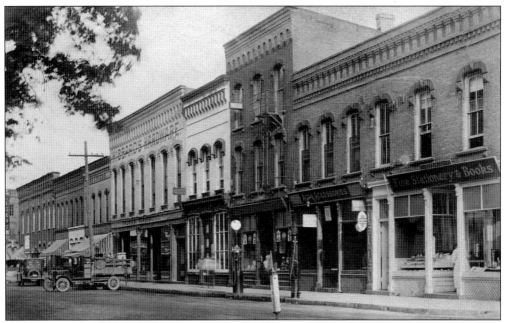

Automobiles and delivery trucks drive on brick-paved streets in this early-1920s photograph. Early gas pumps were located in front of the Auto Accessories store near the corner of West Franklin Street and Church Street (now Grand Central Avenue). T.J. Wintermute & Co. (right) offered "Fine Stationery and Books."

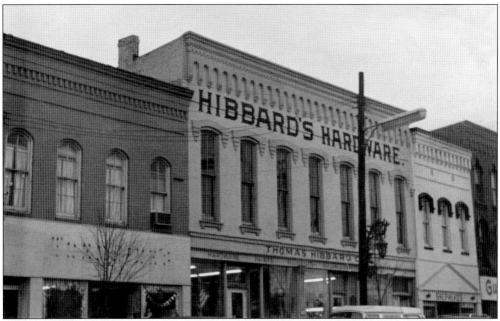

Hibbard's Hardware was an institution in Hanover Square for more than 100 years. It was founded in 1871 by Thomas Hibbard and Frank Lovell. In 1904, the business moved from Main Street to this double storefront on West Franklin Street. In 1950, after her father's death, Maude Hibbard Judson ran the store and was an icon on Hanover Square until her death in 1967. Tom Lynch continued the business until his retirement in 1989.

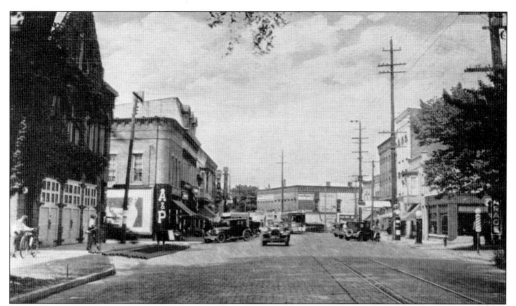

Hanover Square is seen here bustling with traffic in the 1920s. The A&P store on the corner of John and Main Streets was the first commercial grocery to come to Horseheads.

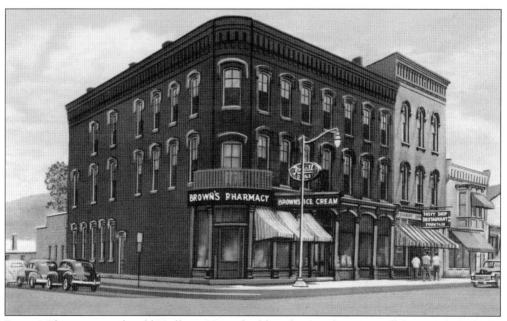

Brown's Pharmacy, in the old Hoffman House building, became known to all for its soda fountain and homemade ice cream. Apartments were located upstairs. The Masonic temple was above the Tasty Shop Restaurant and now occupies all floors of the building.

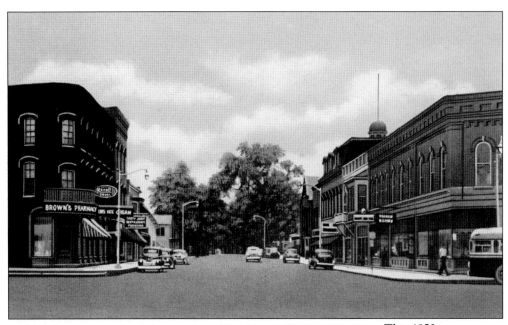

This 1950s scene shows new, modern streetlamps, the bus stop at Rudy Baer's corner (right), and the brick fire station at John and Main Streets.

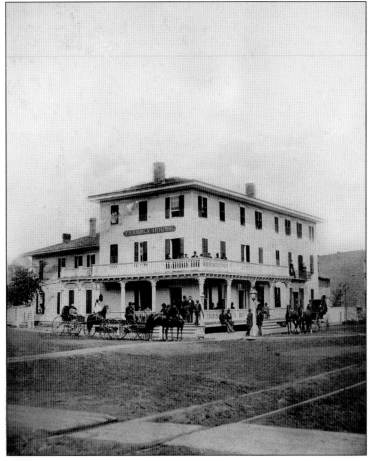

The Trembley House replaced the Colwell Hotel, which burned down in the great fire of 1862. The fire, on August 12, started in one of the barns connected to the Colwell and destroyed the entire business district. The Trembley passed through many owners, including Robert Colwell, the Bennett-Burch partnership, just Burch, and then Trembley, which was run by J.L. Patterson. The hotel was situated parallel to Main Street.

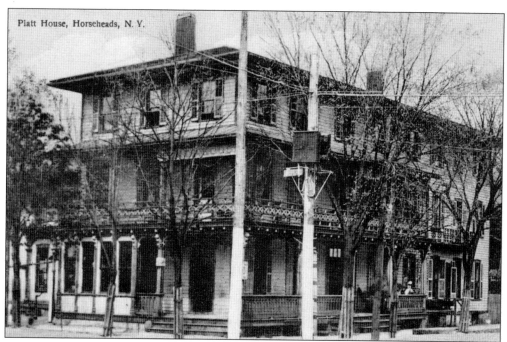

In 1880, Rufus Platt bought the Trembley House. The Platt House was the most famous of Horseheads hotels, hosting many political and social events. In 1904, the last great ball was held at the Platt House to celebrate the installation of water and electricity in the village.

This Platt House advertisement boasts, "Largest and best hotel in Horseheads with special attention to car parties." Jerome Platt (1848–1917) was the proprietor in its heyday. His funeral was held in the hotel. The Platt House was torn down in 1927 to make way for the First National Bank.

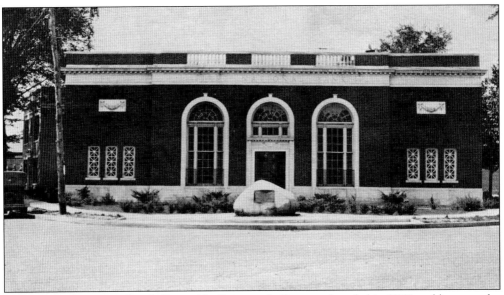

The first bank in Horseheads, Reynolds, Bennett & Co., was founded in 1869 and became the First National Bank in 1906. A new Federal-style brick bank was built diagonally on the site of the Platt Hotel in 1927. Elmira Bank and Trust eventually acquired the bank, and it was later known as Marine Midland. Law offices now occupy the bank building.

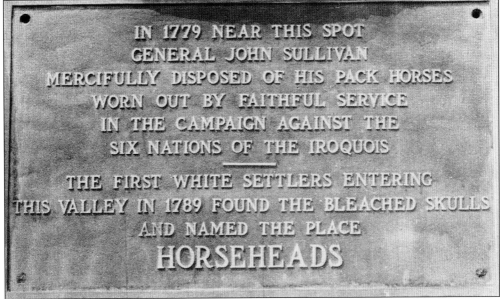

In 1927, during the excavation of the new bank, a huge boulder was unearthed. The dilemma of what to do with it was noticed by Eugene "Zim" Zimmerman from his Correspondence School office upstairs across the street. Zimmerman suggested to bank president Frank Campbell that it stay and become a monument to the origin of Horseheads. (Photograph by Marcia Tinker.)

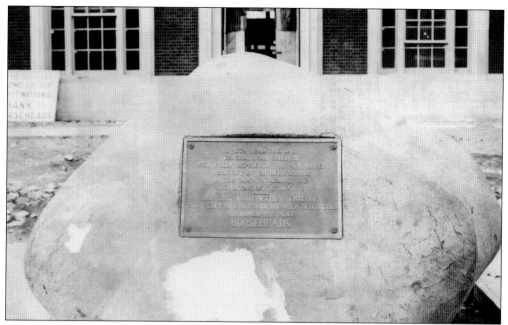

The Rock at the Square was set in place in front of the newly built First National Bank in 1927. Ever since then, the rock has been a major Horseheads landmark. (Courtesy of the Chemung Valley History Museum.)

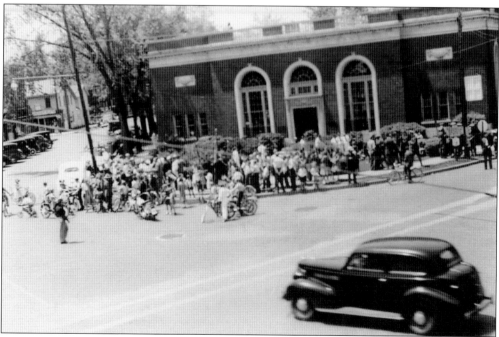

More than 1,000 people attended the 1928 dedication of the monument in Hanover Square. Village officials, "Zim" Zimmerman, and many citizens attended the celebration honoring General Sullivan's packhorses. Dr. E.A. Bates, the founder of the Indian Welfare Society, spoke on Indian lore, and three Onondaga Indians danced four tribal dances in full costume. (Courtesy of the Chemung Valley History Museum.)

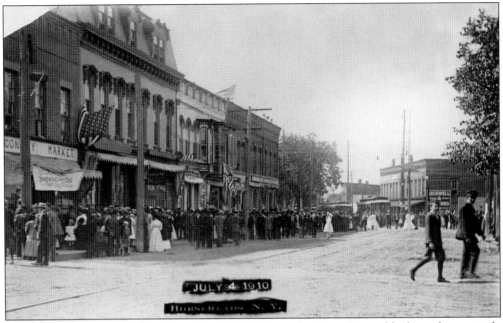

This view north on Main Street on July 4, 1910, shows the Ryant House block on the west side of Main Street. It was comprised of a bar and general store, three grocery stores, a drugstore, and a variety store.

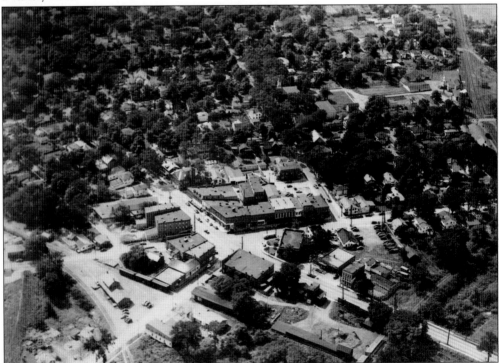

This 1940s aerial view of Hanover Square shows the large "square" formed where the five streets meet. The Lehigh Valley station is in the lower left. The railroad tracks in the lower right run next to the Judson coal yard and follow the bed of the Feeder Canal. (Courtesy of Richard Margeson.)

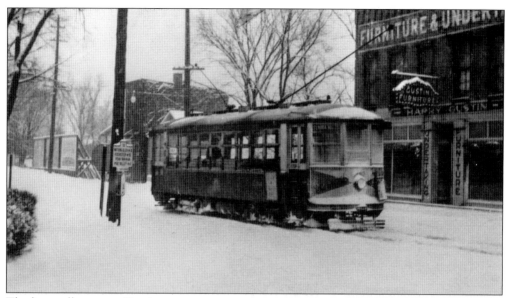

The last trolley passes Gustin Furniture and Undertaking through the snow at Main Street and Ithaca Road. The Judson coal yard and railroad crossing is in the background. This snowstorm, on January 30, 1939, put the Horseheads trolley line out of business.

Park & Meyers, seen here in the late 1890s, was on the southwest side of Franklin Street. William Park and E.M. Myers ran the business. It later became Myers Bros. Groceries and Dry Goods. In 1918, when Walter Myers became the proprietor, groceries were discontinued and it became a small department and dry goods store. Horseheads historian Nadine Ferraioli, the granddaughter of Walter Myers, worked there as a girl.

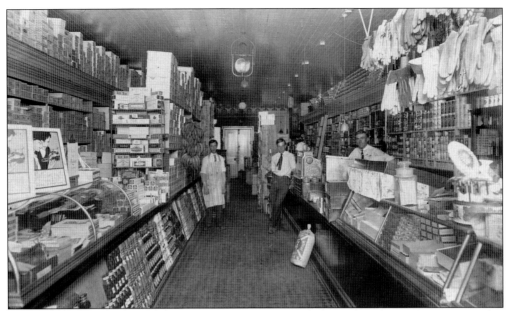

The interior of the Park & Myers store is seen here in 1908 or 1909. An early-1900s advertisement for the store claimed, "It would be difficult to find a better selected or more salable line of Groceries, Teas, Coffees, Cigars, etc. They also carry a fine line of M.W. Dodge's Men and Boy's Shoes, and Hough & Ford's Ladies Shoes."

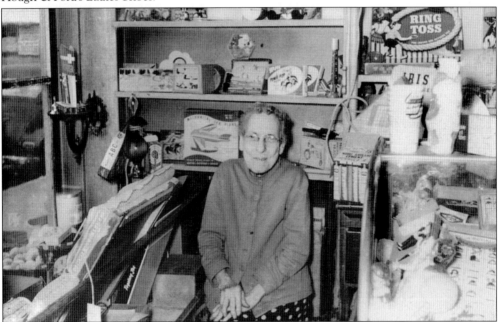

Minnie Corel ran a variety store out of her father, A.M. Corel's, drugstore in the 1920s and 1930s, later moving into her own store around the corner on West Franklin Street. In her Bygone Days column, Nadine Ferraioli remembers, "Her two windows were loaded with 'penny' candy treasures. There were things that were there since her dad had the store, and if you'd give Minnie enough time she'd 'unearth' anything you needed. She always had a friend or two sitting on the stool and chair she had back in the corner." Wade's Jewelry is now at the location of Minnie Corel's store.

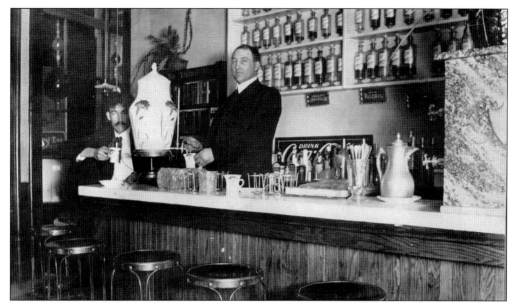

Charlie Brown, the owner of Brown's Pharmacy, stands behind the World War I–era soda fountain. Brown's operated from the early 1900s until 1960 in the former Hoffman House building. In 1944, the first lending library, organized by the Horseheads Woman's Club, moved in upstairs above the drugstore.

The original Rosar Grill, a tearoom, was owned and operated by Minnie Rosar on John Street. She opened the grill in the 1920s, did all her own cooking, and served breakfast, lunch, and dinner. A blue plate luncheon special was 50¢. The post office was located next door. In 1945, Rosar sold her business to her nephew Allen Edwards, and the Rosar Grill is still there today.

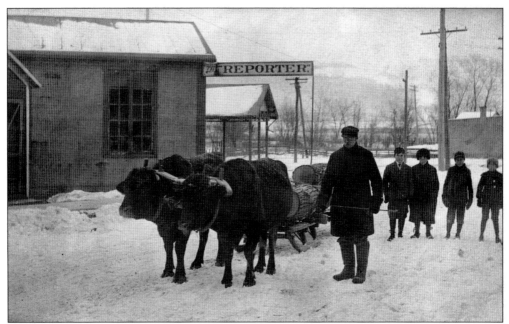

An oxen sled passes the *Chemung Valley Reporter* office on East Franklin Street in the late 1890s. The sole newspaper in Horseheads, it was founded in 1863. George Mulford was a prominent Horseheads editor and historian until his death in 1927. The *Reporter* occupied several locations in Hanover Square over the years.

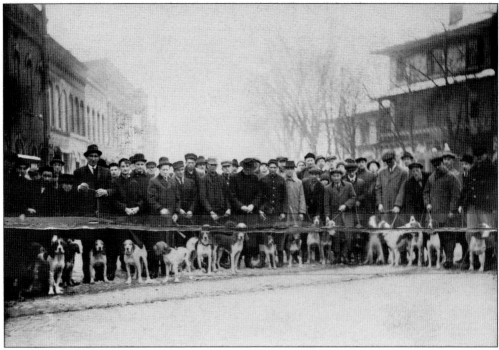

A 1920s foxhunting group poses in front of the Platt House. Fox hunts were popular entertainment for Horseheads men. A prize of $5 was given to the owner of the dog that caught the fox first. Mort Bentley, Lou Gardener, and Rufus Edminster are members of the large group seen here.

Dr. Charles W. Cox, seen here, had his dentist's office at the corner of Franklin Street and Main Street, over Hibbard's Hardware, from 1900 to 1920.

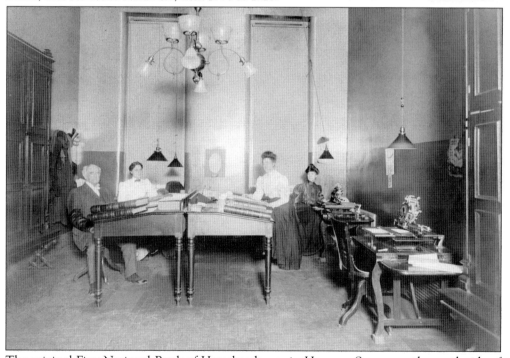

The original First National Bank of Horseheads was in Hanover Square on the south side of Franklin Street. Here, Ambrose Carpenter (left) and Harriet Newcomb (second from left) are at work in the bank office in the early 1900s.

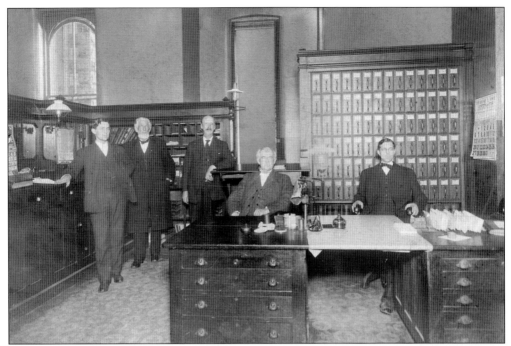

The interior of the old First National Bank on Franklin Street is seen here, In 1927, the bank moved to a new building across the street.

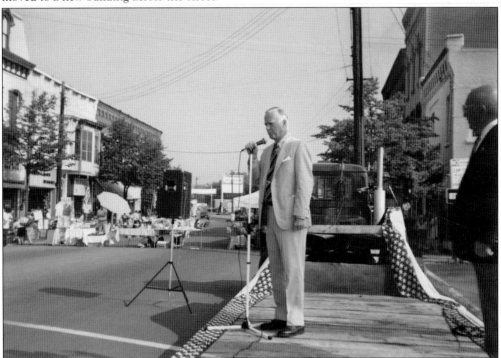

Congressman Amory Houghton addresses a gathering in Hanover Square during the yearlong celebration in 1987 marking the 150th anniversary of Horseheads' 1837 incorporation. This view looks north on Main Street.

Four
INDUSTRY AND COMMERCE

The Valley of the Horses' Heads boomed after the Chemung Canal and railroads developed. Local farmers also discovered that they had farmland capable of growing a popular delicacy, celery. Businessman W.H. Smith established the Horseheads Celery Company and shipped large quantities of celery and other local produce from Maine to Florida.

Horseheads also became known for the manufacturing of quality bricks. In 1840, a man named Albright started the first brickyard, which was primarily used by local farmers for their own needs. Benjamin and William Westlake purchased the brick business in the 1850s and developed the largest plant in the state. Benjamin built an ornate mansion and grounds adjacent to the factory. The Westlakes were succeeded by Smith Manufacturing Company, which was acquired by R.G. Eisenhart in 1890. Because of their high quality, Horseheads bricks were sought after for more than a century. Architect Eero Saarinen used them in his designs for the entire campus of Concordia Senior College (now Concordia Theological Seminary) in Fort Wayne, Indiana. Eisenhart sold the company to George and James Prindible in 1920, and it later passed on to Clarence and Charles Austin before closing in 1961.

World War II brought drastic change to the Horseheads landscape. The boggy farmlands were purchased and filled in by the Army, which built a 700-acre supply depot north of the village in 1941. The $8 million supply depot employed more than 2,000 people at its height. At the end of the war, it was sold to private concerns, creating a large industrial site, known as the Holding Point, or Horseheads Industrial Center. Many industries have called it home. National Homes built prefabricated houses there for local housing developments such as Windsor Gardens.

Horseheads has been home to many industries, from early blacksmiths and carriage makers to grain mills, lumber mills, and foundries. Winchester Optical was a manufacturer of eyeglass products. Other industries in the area produced sailplanes, electronics, and television tubes.

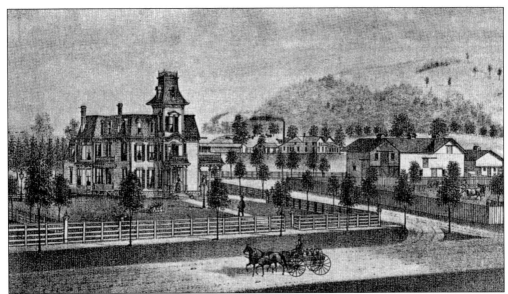

This etching depicts the farm and stately residence of Col. Henry C. Hoffman, which stretched from Newtown Creek east on Franklin Street. Hoffman was the first breeder of Holstein cattle in the area and was also known for his vast celery fields. This farmland is now owned by the New York State Department of Corrections.

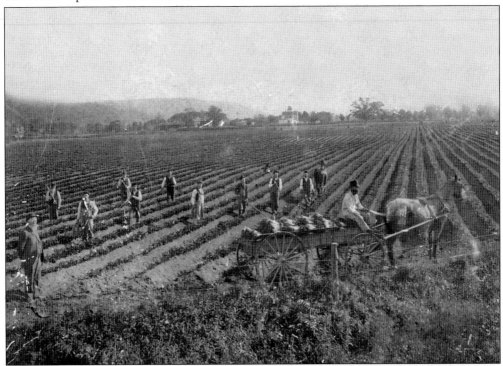

Colonel Hoffman's rich "muck" fields benefited from Newtown Creek's spring floods, making for perfect celery-growing conditions. Because of the thick, rich mud, horses wore "muck shoes," similar to snowshoes. Here, Colonel Hoffman drives the horse wagon while farmhands harvest the celery. Hoffman's estate, barns, and outbuildings are in the distance.

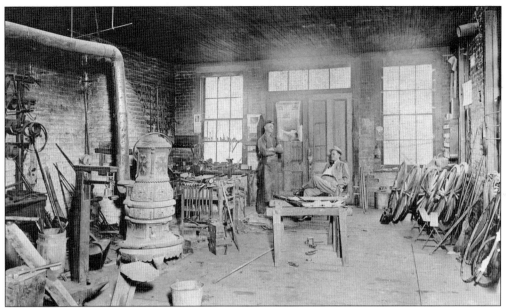

Edward K. Van Gorden's blacksmith shop was frequented by Horseheads political cartoonist Eugene "Zim" Zimmerman (seated). Located at 109 John Street, the business specialized in wagon and carriage repair from the late 1880s until 1930. The shop was also a center for local businessmen to socialize. Van Gorden (standing) was given the title of honorary president of the Sunshine Club.

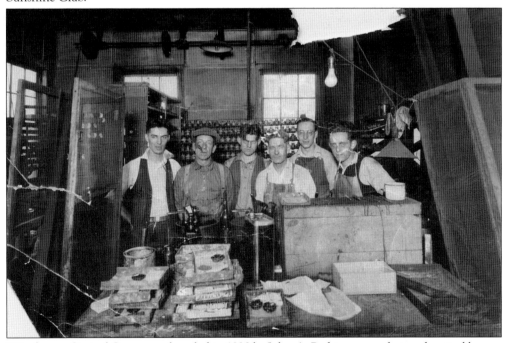

Winchester Optical Company, founded in 1898 by John A. Perkins, manufactured optical lenses. It operated out of the long wooden building that still stands next to the railroad tracks on West Franklin Street. Allyn B. Frost (far left) and Jake Guth (third from left) are seen here with other, unidentified employees. (Courtesy of Susie Frost Driscoll.)

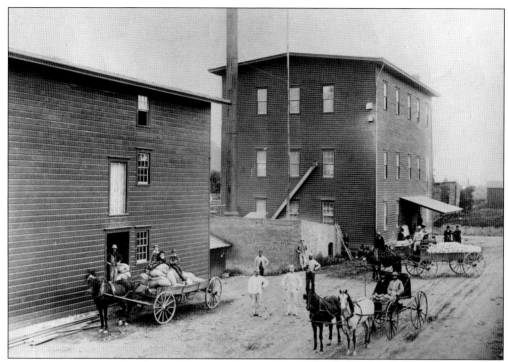

The Tuttle Lumber Company was founded by W.E. Tuttle in 1868. The company, which was in operation for more than a century, advertised itself as, "Planing and saw mills and manufacturer and dealer in Pine, Hemlock, Ash, Basswood, Oak, Maple and Elm lumber." It was located between East Mill and Adams Streets.

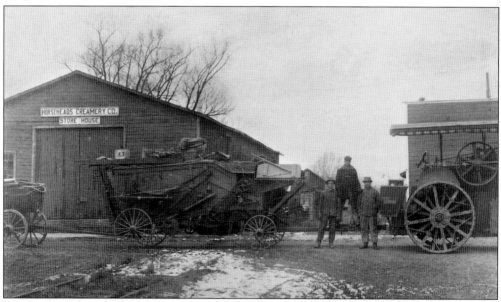

Horseheads Creamery Co., owned by O.D. Eisenhart, was located just off Hanover Square. This 1917 photograph shows a steam engine pulling threshing equipment. The man in the center is identified as Nowed Beardslee. The creamery sold groceries, meat, fruit, produce, cigars, tobacco, and candy.

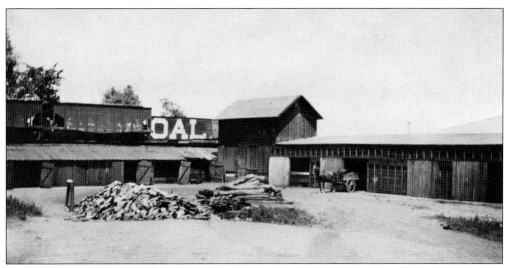

The Judson Coal Co., at 120 North Main Street, was operated by Clayton and Maude Judson after purchasing it from Jesse L. Peck in 1917. They sold ice, wood, and coal. This 1934 photograph shows the coal being delivered by the railroad, which dumped coal from above into the coal yard bins. Maude Judson operated the business after her husband's death, from 1951 until 1954.

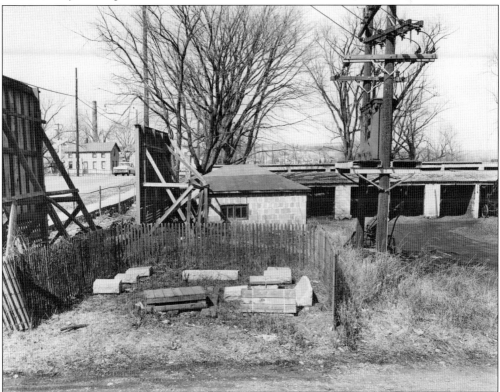

This 1954 view looks north from the Judson coal yard. The smokestack of the Horseheads brickyard is in the distance. The next lot north became the site of the current village fire department. The Grand Union grocery store was built at this location in 1954 and operated until 1973. The Horseheads Do It Center uses that space today.

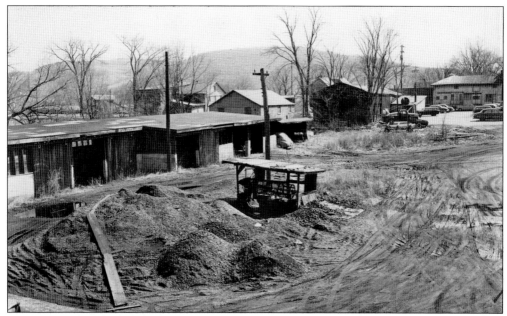

In this image looking southeast from the Judson coal yard in 1954, Ithaca Road appears largely undeveloped. This vacant lot became a small plaza and is now Tanino Ristorante Italiano. On the far right are the backs of some of Hanover Square's Main Street businesses.

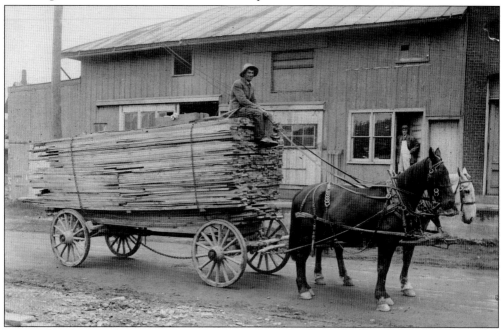

Rockwell and Sayre Manufacturing Co., also known as the Horseheads Screen Door Factory, was located at the West Junction, on Chemung Street. George W. Rockwell and E.M. Sayre began the business in 1889. They were best known for the Perfection screen doors and windows, which were advertised as the "best and strongest on the market." Rockwell operated the business without Sayre from 1900 to 1910. Overall, Rockwell was in the hardware business for more than 50 years, starting with a tin shop and hardware store in 1880.

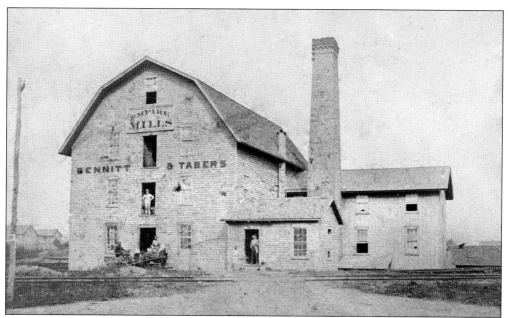

The Empire Feed Mill was originally built by John Hastings on the east side of Main Street, and in 1850, he moved it to the north side of Franklin Street. It was run by George and Morris Bennett from 1857 until 1861, when it was destroyed by fire. Later, it was operated by Bennitt, Taber & Co. before again burning in an 1880 fire.

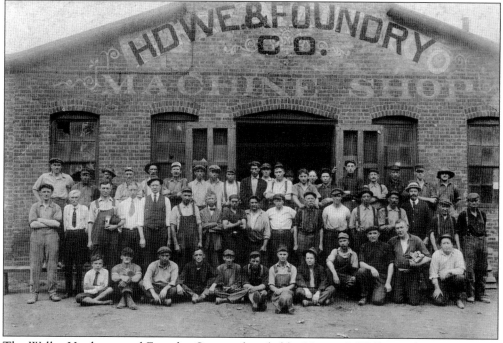

The Weller Hardware and Foundry Co. was founded by Horace J. Weller in the 1870s. It was later operated by his sons-in-law, Frank L. Mathews and W.W. Myers. The foundry was on South Main Street, on the Lehigh Valley siding, until the 1940s. This 1902 photograph shows the large number of men employed by the foundry.

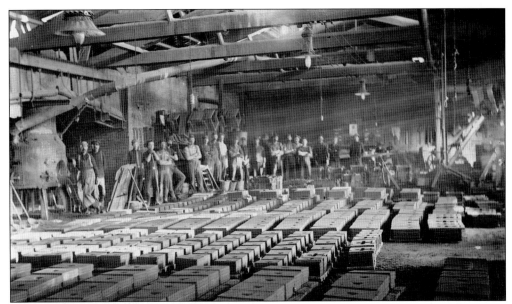

This interior view of the Weller foundry in 1912 shows workers posing behind stacks of iron plates. The foundry manufactured gray iron, semisteel, and nickel chrome castings for many local factories. The foundry was at what is now the 700 block of South Main Street, next to the current post office.

The staff and employees of the George Case Company stand in front of the company office on South Avenue in 1929. They are, from left to right, Charles J. Blackwell, Orvia Root, Blondie Sorenson, Dexter Stanton, unidentified, unidentified, Bessie Nichols, unidentified, Ethel Welch, Satie Evenden, Harold Staples, four unidentified, and George Case. Blackwell was a dealer in heavy road equipment, as was Case.

Here, George Case is the subject of one of Eugene "Zim" Zimmerman's anecdotal caricatures. Not many Horseheads businessmen escaped Zim's pen and brush, and Case was lucky, as this sketch is closer to a portrait. Zimmerman usually added biographically descriptive elements to drawings of his cronies. Many of these caricatures of locals are on display at the historical museum and at the Masonic hall.

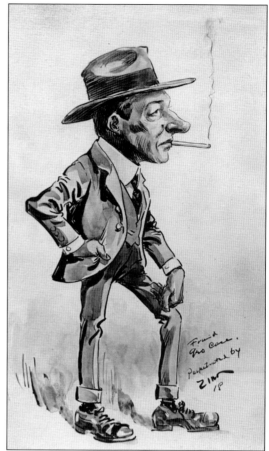

This Standard Oil pump station was located at the West Junction, on Chemung Street, the current site of the Chemung County office buildings. The pump station was on the first major New York oil pipeline, which was laid from 1878 to 1880 and stretched from Olean to Port Jervis.

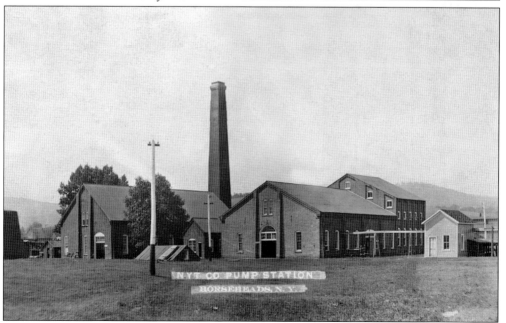

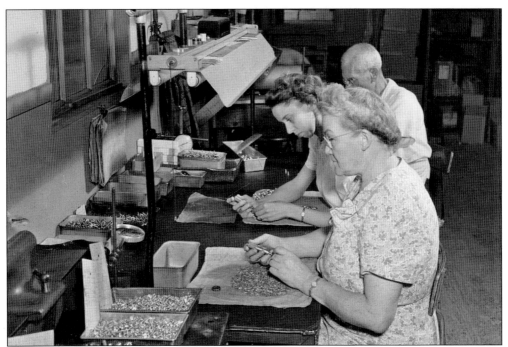

The Commercial Screw Machine Products Company was formed in 1951 by skilled machinist Charles L. Shull, employing 55 people. Shull was an inventor as well as manufacturer. In 1952, he received a patent for a screw-and-nut mechanism that was used in the radar and electronics industries. Major customers were Corning Glass, RCA, Sylvania, and IBM.

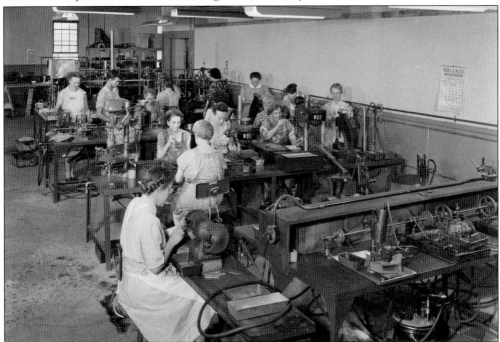

Employees work at the screw factory in 1950. Located at 901 South Avenue, the business was sold in 1964 and evolved into LRC Electronics, Inc.

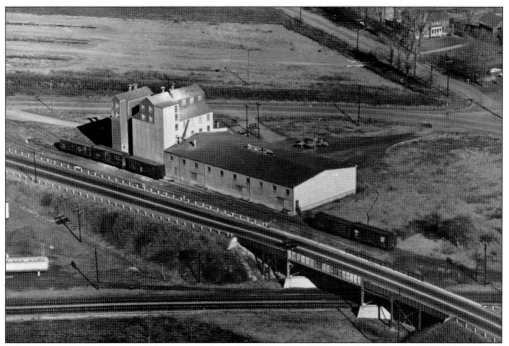

The Dean and Lee feed mill was built in 1946 by Herbert and Harry Kahler at the West Junction. A Lehigh Valley Railroad siding serviced the mill. In 1968, it was sold to Robert J. and son Marc H. Hample for their restaurant supply business. Today, it is the home of Carpet Warehouse.

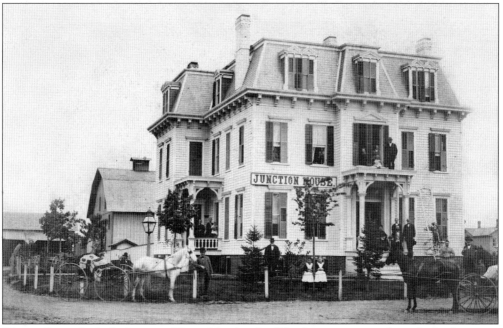

Ulysses Breese built the Junction House Hotel at the West Junction, across from the Lackawanna Railroad station. Breese was one of 99 grandchildren of Horseheads' first settlers, John and Hannah Breese. The third floor of the hotel was a dance hall. After a fire in the 1970s, the top two floors were removed. The building is now home to Stoney's Casa Blanca.

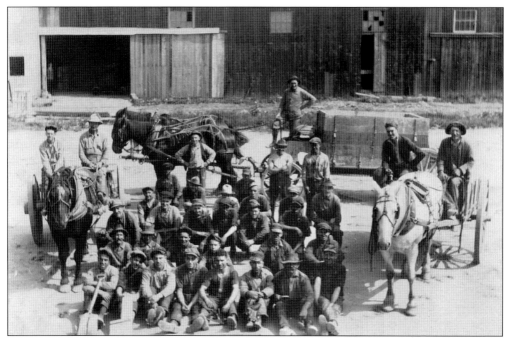
According to the 1891 manufacturers directory, the Horseheads Brickyard employed 60 men and 14 teams of horses. In this 1922 photograph, brick workers pose in front of the barns with three of the horse teams. (Courtesy of Susie Frost Driscoll.)

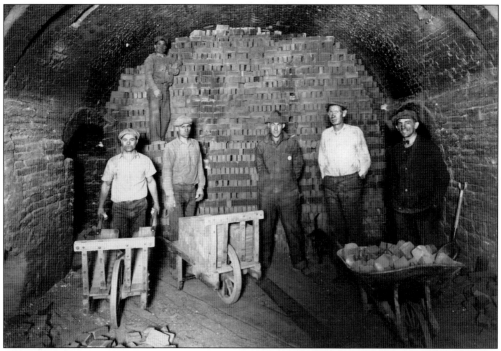
The wheeling gang loads bricks in a kiln in the 1920s. Seen here, from left to right, are three unidentified men, Nick Giammichele, Ernest Struble, and Joe Ziegler. (Courtesy of Susie Frost Driscoll.)

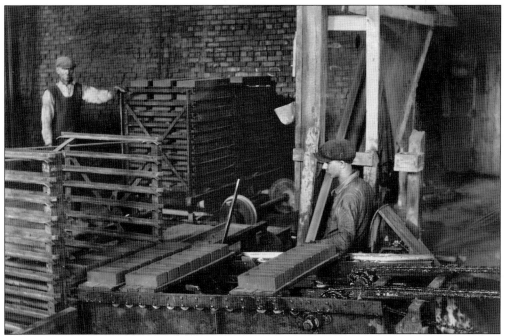

Horseheads bricks were of such high quality because raw materials were readily available in the area. Superior clay came from the clay "dingy" pits on Gardner Road, and shale came from Watkins Road, near Wygant Road. Both were transported to the brickyard by a small railroad. In this photograph, bricks are being loaded for firing.

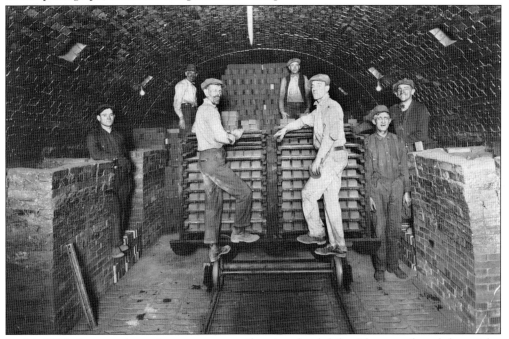

In this 1926 photograph, workers pose on a railcar in a brick kiln. They are, from left to right, James Jessup, Robert Breon, Theodore Burgett, Joe Solomto, Bert Baldwin, Lew Cogsill, and Joe Ziegler.

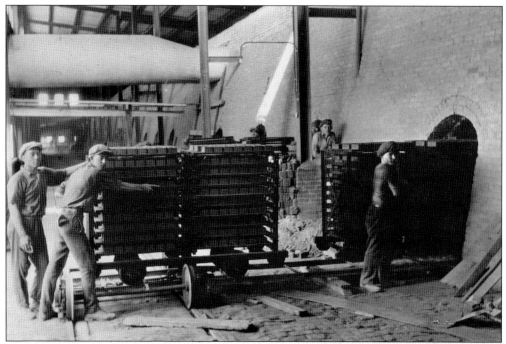

The Horseheads Brickyard complex covered 220 acres. The main buildings, dry houses, and sheds were built on two and a half acres. Bricks were loaded on railcars before going into the kilns for firing.

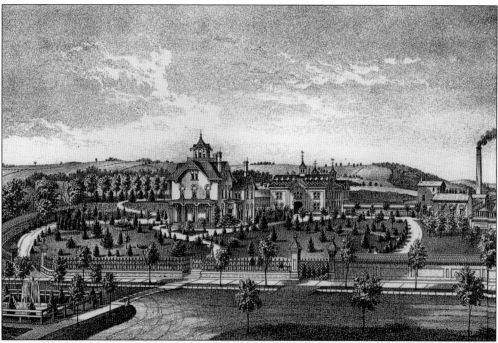

In 1854, Benjamin Westlake built a picturesque brick Victorian mansion and barns on the premises of the brick company. This showplace was surrounded by lavish gardens, brick walls, and walkways. The magnificence of that era is depicted in this etching from the late 1800s.

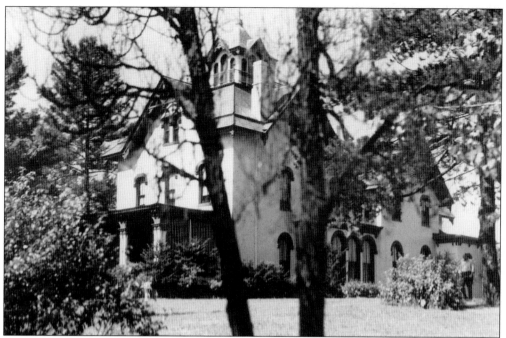

The Westlake-Eisenhart estate was a Horseheads landmark for more than 100 years. In this 1949 photograph, it is still a stately mansion. In the 1940s, the Crystal Manor Restaurant operated in the house.

This 1949 photograph, looking west from the Westlake-Eisenhart mansion, shows the ornate carriage house on the estate. A Greek Revival home is also in the distance.

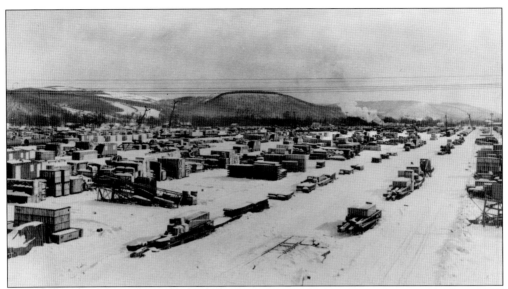

The Elmira Holding and Reconsignment Point, known as the Holding Point, was built in 1942. This 700-acre plot was accessed by 37 miles of railroad track and had ample storage for war material. This war department photograph shows the vastness of the facility. (Courtesy of the *Elmira Star-Gazette*.)

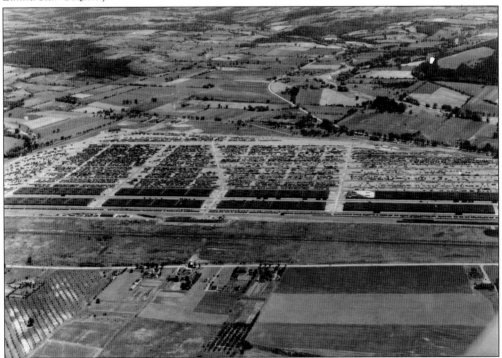

Looking east, this aerial view of the Holding Point during World War II shows the farmland still surrounding it. Watkins Road is in the foreground, and the large estate in the foreground center is the Miller Villa, with the apple orchard on the far left, which is now Apple Ridge and Bethany. Between Watkins Road and the Holding Point is the swamp in which Sullivan's troops had traveled. Ithaca Road is in the upper right.

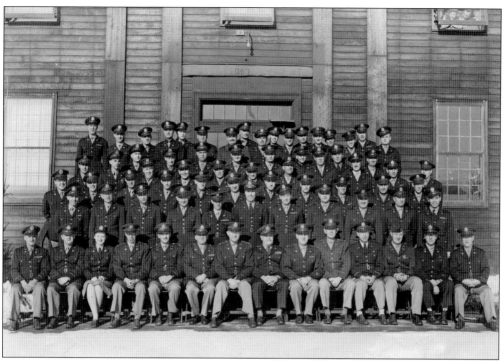

Officers pose in front of the Holding Point headquarters during World War II. More than 1,200 civilians and 120 military personnel were employed by the Army Transportation Corps.

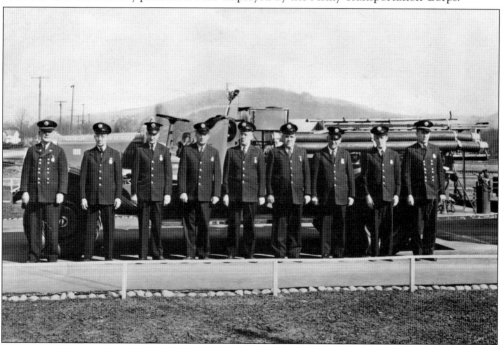

The Holding Point required its own fire department, seen here around 1945. It includes, from left to right, unidentified, unidentified, Mose Briggs, George Sullivan, Chief Art McGee, unidentified, unidentified, Clauson Hargrave, and unidentified.

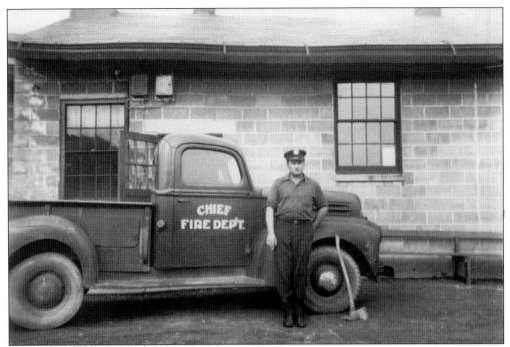

George Sullivan, the longtime chief of the Horseheads Fire Department, stands in front of the Holding Point fire station during World War II. The Sullivan family has led Horseheads firefighting efforts for decades. George operated Sullivan Bros. Trucking with his brother Art and was also a collector of steam and fire engines. He died on June 2, 1979.

The US Army engine house at the south end of the industrial center is seen here in 1982.

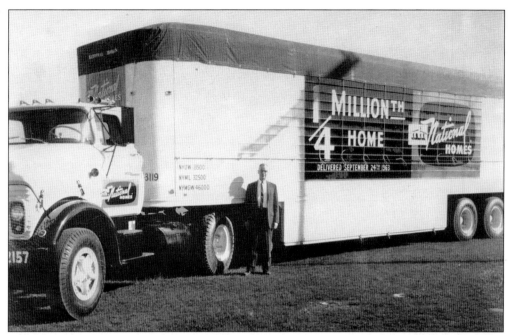

After the war, the Holding Point was sold to Webster Industries for $1.3 million. Since then, many businesses have operated at the Horseheads Industrial Center, including Corning Glass, Frosted Foods, and the National Homes Corporation, which manufactured prefabricated homes from 1950 through the 1960s.

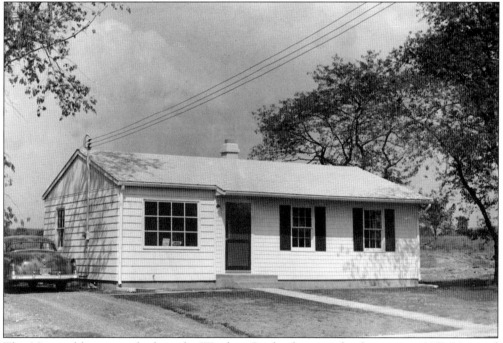

This National home was built in the Windsor Garden housing development in 1959. National Homes began this housing development in 1953, turning farmlands into subdivisions. (Photograph by Harry Butters.)

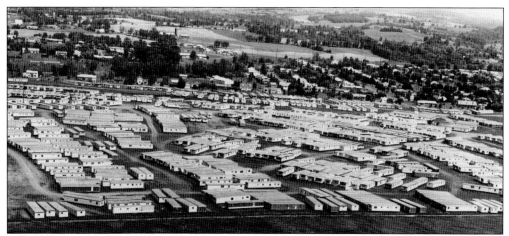

After Hurricane Agnes and the flood of June 1972, the Horseheads Industrial Center was the staging area for Department of Housing and Urban Development (HUD) trailers.

The Arnot Mall was built in 1967 on 40 acres of farmland on Chambers Road. It was the first enclosed shopping center between Rochester and New York City. Developed by Arnot Realty and constructed by Welliver Construction Co., it had 34 stores, with JC Penney as the anchor. Today, Arnot Mall consists of over 100 stores.

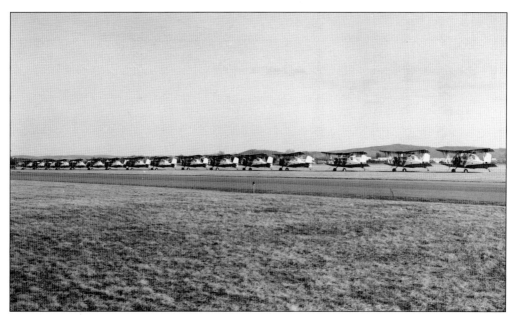

Schweitzer Aircraft Corporation helped make Chemung County known as the Soaring Capital of America. The Schweitzer brothers, William, Paul, and Ernest, brought their aviation manufacturing business to the area in 1939. Known for soaring, sailplanes, and the Grumman Ag Cats, their factory was adjacent to the Chemung County Airport. They also operated a glider school seven months of the year.

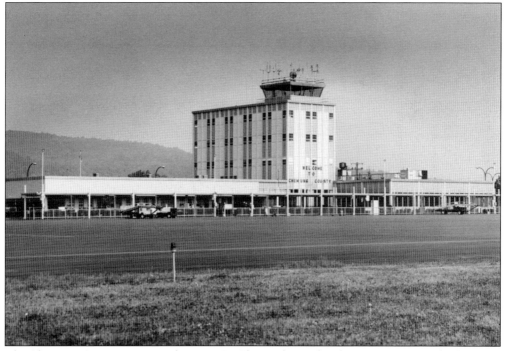

The Chemung County Airport is between Big Flats and Horseheads on Sing Sing Road. It began as an emergency airstrip in a grassy field. American Airlines built the first airport there in 1933. Now known as the Elmira-Corning Airport, it is referred to as the Gateway to the Finger Lakes.

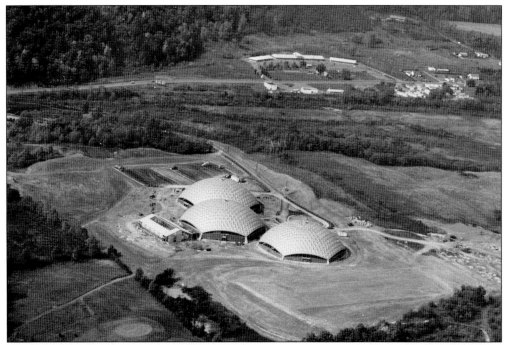

Elmira College built the Murray Athletic Education Center, the Domes, in part of the swampland that General Sullivan and his troops trudged through during their campaign. In the top of the photograph is Watkins Road and the Hickory House, and in the bottom left corner is the Soaring Eagles State Park golf course.

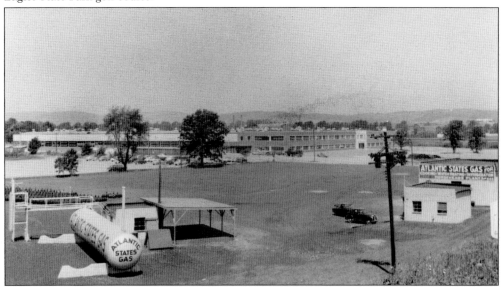

In 1951, Horseheads was chosen as a location for the new electronic tube division of the Westinghouse Electric Corporation. The 110-acre site of former farmland was bordered by Route 17, the Erie Railroad, and the Delaware, Lackawanna & Western Railroad. The electronic tubes produced ranged from early "electric eye" tubes for defense to vacuum tubes. In 1974, the entertainment tube division was added to make color television tubes. This photograph looks west at the newly completed plant from Route 14, which was nicknamed the Miracle Mile because of its rapid business growth.

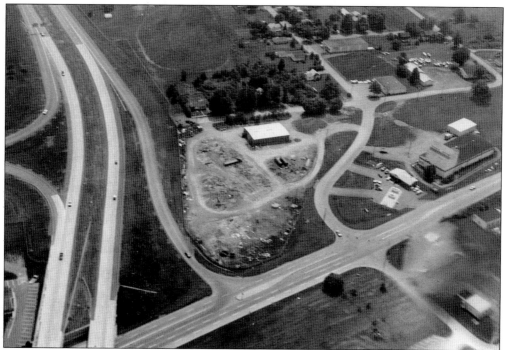

This early-1960s aerial photograph shows the eastern portion of the Southern Tier Expressway (Route 17) as it passes through Horseheads. Route 17 was built to connect western New York to the eastern New York metropolitan region. Between 1949 and 1975, the highway was developed from an old two-lane road into a major four-lane highway. This photograph shows the new overpasses that were built over the Pennsylvania Railroad tracks. At this time, Route 17 passed through Horseheads with a series of stoplights. The road in the foreground is the Miracle Mile (Route 14), and Chemung Street is in the upper right corner.

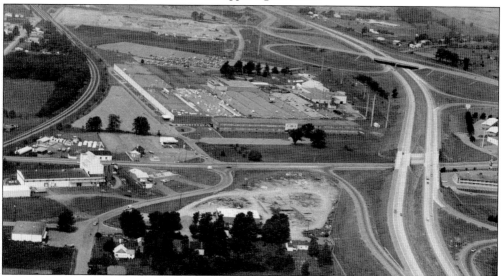

This aerial view looks west at the area referred to as the West Junction, with the new Route 17 running east to west. The large complex is the newly built Westinghouse plant. The Miracle Mile of Route 14 crosses north to south as it passes the feed mill. Chemung Street is in the lower left.

The Miracle Mile of Route 14 was so named because of the rapid growth of businesses between Horseheads and Elmira Heights. In this south-facing photograph, the Super Duper grocery store and Clute Ford are on the left. On the right are Carroll's Drive-In and Edgecomb's Furniture.

The residential area that developed to the west of the Miracle Mile is seen in this photograph, looking north up the road. The Lackawanna Railroad tracks run parallel, going to West Junction.

Five
SCHOOLS, CHURCHES, AND HOMES

Horseheads grew steadily from the days of the early pioneers, and it has always had a rich history of schools, churches, and homes. Amelia Parkhurst taught the very first school in the log cabin built by John Breese, the first settler.

In his 1807 deed, Nathan Teal designates a parcel of his landholdings to "the use of the inhabitants thereof." In 1815, the Teal school, a two-story frame community building, was built for church and school functions. In 1850, a four-room school was built next to the original building and was used for the next 42 years. Teal Park is now a Horseheads Village park, continuing Teal's intention.

The first preacher, Rev. Roswell Goff, ministered needs of both whites and Indians as early as 1805. The Marsh Church, built on Wygant Road in 1827, was the first Horseheads church building and led to the 1840 formation of the Baptist church. First United Methodist began in 1815 and incorporated in 1834, meeting in the Teal school. Also organized at the schoolhouse was First Presbyterian, in 1832. Baptist, Methodist, and Presbyterian churches were built on Church Street (now Grand Central Avenue) in the early 1800s. St. Mary's Church was erected in 1866 at 816 West Broad Street, as a mission of SS. Peter and Paul in Elmira. St. Mathew's Episcopal held its first services at the Mathew Sayre estate and built a church on Main Street in 1865.

Land was acquired and the first homes were built 10 years after General Sullivan passed through the area. The first pioneer families, including the Conklings, Shutes, Breeses, Sayres, and McConnells, were paid in land through the Soldier's Claim Act. The village grew as the canal system and railroads brought industry and more settlers. Homes of the early 1800s were built in the Greek Revival style, and by the mid-1800s, the Gothic Revival style was popular. The Italianate influence is also seen in the mid-1800s homes in the center of Horseheads. By the end of the 1800s, the Queen Anne Victorian style was common.

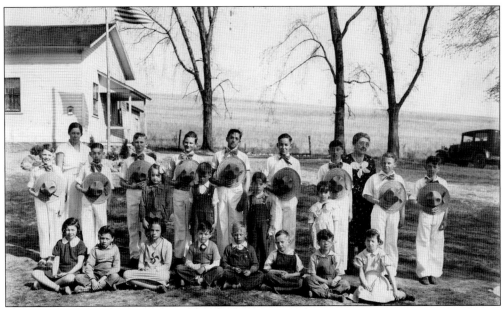

One-room schools surrounded the Horseheads area, serving the rural populations. Bessie and Harriet Nichols attended the district's Hickory Grove School in 1902, walking a mile and a half from their farm each day. The one-room school was heated by a potbelly stove, drinking water came from a shared dipper, and two outhouses were behind the school.

Horseheads Slabtown School No. 8, seen here in 1953–1954, was used until the new Ridge Road Elementary opened in 1954. Because the old building was so near the newly constructed school, the pupils and teachers seen here attended the new school when it opened after Easter vacation in 1954. Due to population growth, a $2.8 million construction project was approved in 1951. Three new grade schools were the result, along with an addition to the high school.

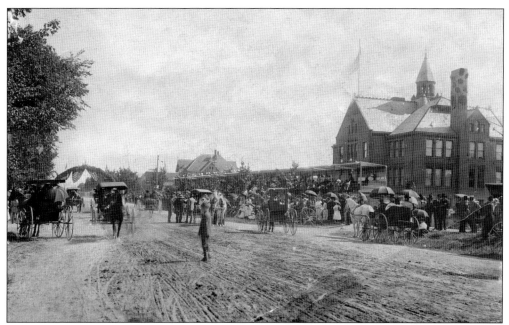

The Horseheads Union School was built in 1891–1892 between Grand Central Avenue and Sayre, Fletcher, and Center Streets. It was designed by architects Pierce and Bickford in the Richardson Romanesque style. Here, a crowd gathers around parade grandstands for a firemen's convention parade in the late 1890s. In this photograph, Grand Central Avenue (originally Church Street) is a wide dirt boulevard.

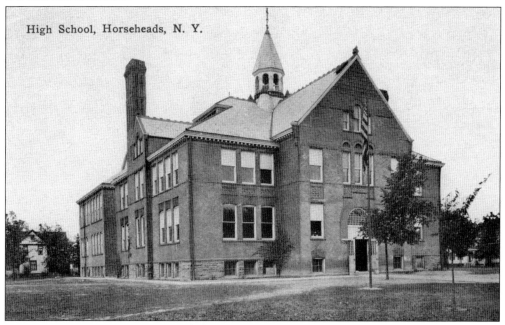

In 1905, it was necessary to expand the Union School with an addition on the Center Street side. It was the only school in Horseheads until 1928, when the new high school was built. The Union School then became known as the annex until it was demolished in 1970. Many grades were housed in the annex, as the student population continued to grow.

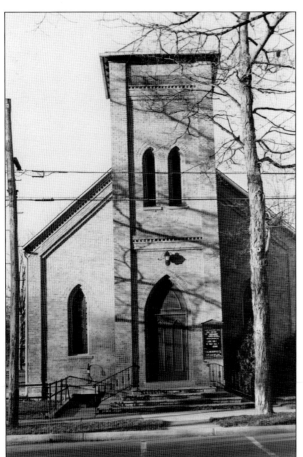

St. Mathew's Episcopal Church was built in 1867. The congregation celebrated its 150th anniversary in 2012 at this historic brick church, at Main and Steuben Streets, across from Teal Park.

The original Methodist church at the location below was in the very plain, white New England style. It was replaced in 1906 with this more elaborate brick church. Bricks were donated by the Eisenharts, of the Horseheads Brickyard. In 1967, the Methodists moved to a new modern church at 1034 West Broad Street.

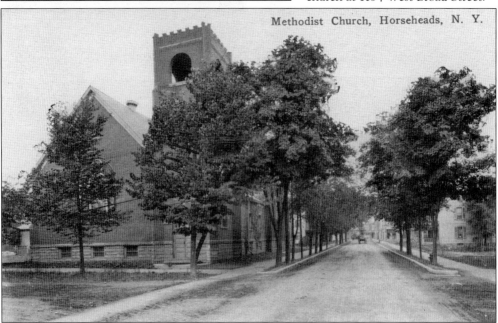

The earliest Presbyterian congregation was formed at the Teal schoolhouse, then moved near the Northern Central depot, and in 1849, built a church at Broad and Church Streets. In 1965, a large modern church was dedicated on Westinghouse Road (Route 14).

The first St. Mary's Church was erected in 1865–1866 and replaced in 1902 by the brick structure seen below. In 1965, the parish became St. Mary Our Mother, and it is now located at 816 West Broad Street along with the St. Mary's parochial school.

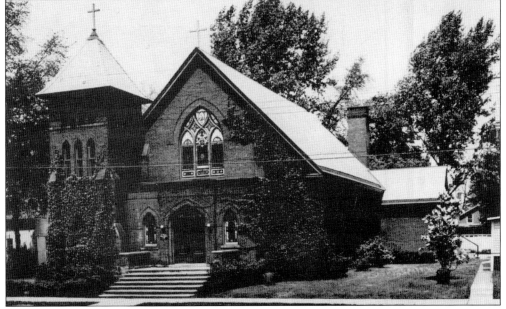

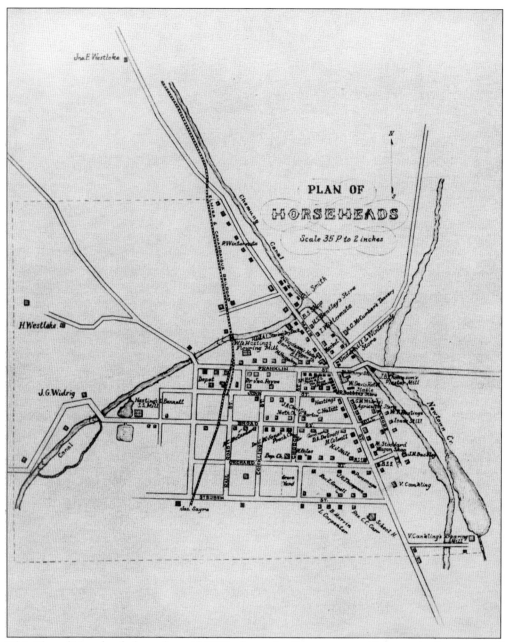

This *Plan of Horseheads* from the mid-1800s shows the first streets and homes. At the corner of Steuben and Main Streets is the Teal schoolhouse. The Elmira Canandaigua Railroad heads north, crossing the Feeder Canal, which connects to the Chemung Canal, which itself then runs parallel to Main Street. Church Street (now Grand Central Avenue) only runs between Orchard and Franklin Streets.

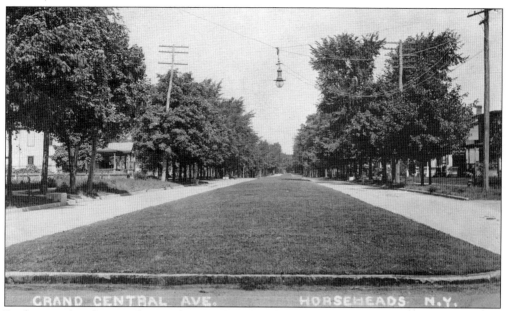

By the time this photograph was taken in 1912, Church Street had become Grand Central Avenue. A wide median separates the north- and southbound lanes, and modern lighting hangs over the center. Over the years, various plantings have appeared in the center of the road.

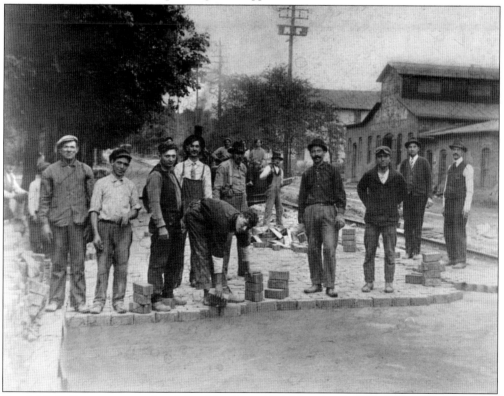

South Main Street was paved with local bricks in 1914. Here, brick is being laid at the corner of Main and Sayre Streets. The Weller foundry is in the background.

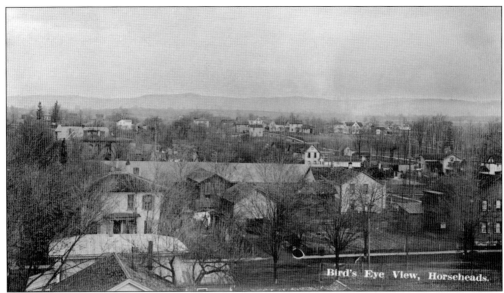

This view looking west from the bell tower of the Methodist church shows Center Street, the Cowell house, the Pennsylvania Railroad station, the VanDuzer house (with windmill), and St. Mary's Catholic Church. On the hill, known as Grasshopper Hill, is the Boorom Place. On the far right are West Franklin and Westlake Streets.

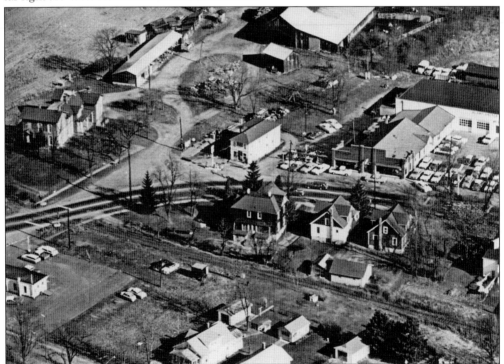

Another bird's-eye view from around 1950 shows the area around Main Street, where it crosses the railroad tracks near Sayre Street and South Avenue. The farm in the left corner is now the site of the post office. The gas station and the car dealership are now a barbershop and a plumbing company, respectively. The railroad tracks in this photograph follow the old canal bed.

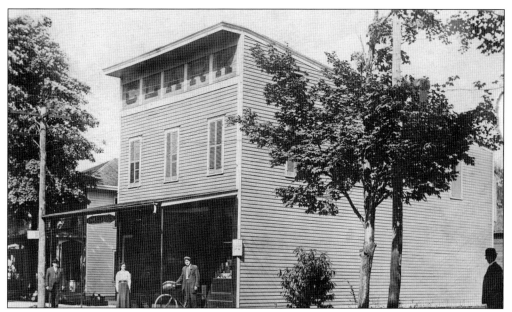

The Clark & Son grocery, at 106 Sayre Street, was one of many mom-and-pop stores on the street. Seen here in 1911, the store later operated as Hamilton's and is now apartments. Through the years, other stores on Sayre Street included Pletcher's, Bricker's, Judson's, Martin's, and Shearer's. Anna Woodard also ran a small store at the corner of Pine and Sayre Streets.

The large, square Personious home, at 134 North Main Street, had been the canal tollhouse during the Chemung Canal era. It is now the site of the village fire station, which was built in 1962. A portion of the old canal can still be seen behind the fire station.

The Hungerford House, at the corner of South Main and Broad Streets, had been a tourist home in the 1920s, known as the Horseheads Inn and owned by Sara Dykes. The Evans Apartments were built there in the 1970s.

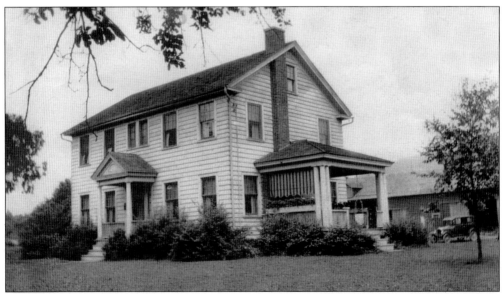

The Wigsten farmhouse and dairy were built in 1921 by Catherine and Frank Wigsten. Their son William and his wife, Gladys, continued the dairy business. Gladys Wigsten was also the first board president of the Horseheads Consolidated School District. The dairy store at 1005 South Main Street was a popular stop.

John Bennett, the president of the First National Bank and onetime owner of the brickyard, owned the estate on the corner of South Main and Mill Streets. Here, Mabel Bennett stands in front of the house, decorated for festivities in the early 1900s. The home was torn down in 1960 to build a branch bank for the Chemung Canal Trust Company.

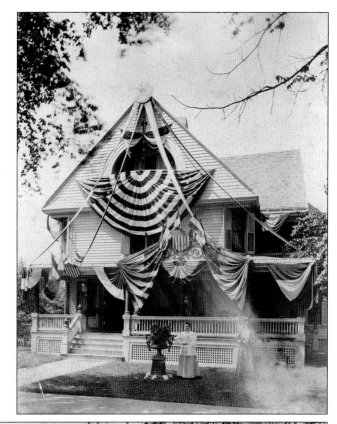

The Bennett home is seen below in 1960, just before it was demolished.

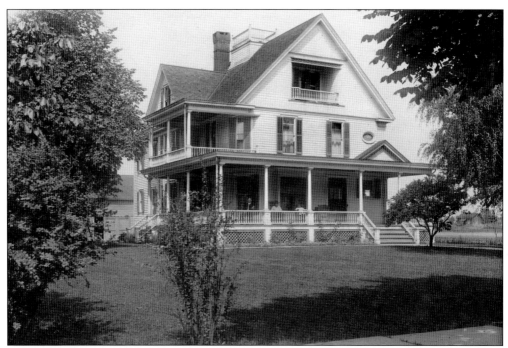

This 1916 photograph shows the Main Street home and farm of Lewis Mosher and Katherine Wanamaker Mosher. The house and farm were later demolished in order to build Route 17 and the Colonial Inn (the Red Carpet Inn today).

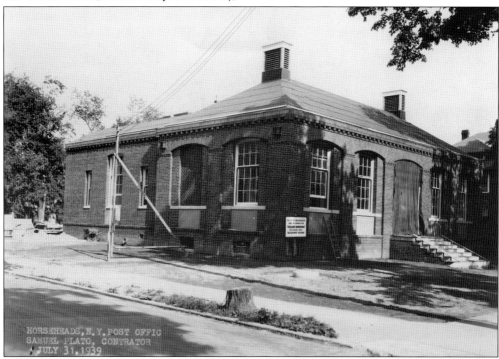

The new Horseheads Post Office was built and dedicated in 1939. The post office had previously been next to the Rosar Grill on John Street.

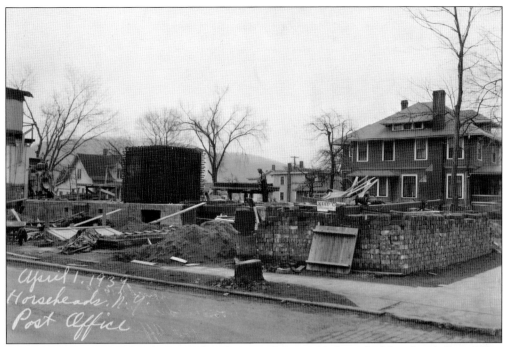

Progress photographs taken by Bogardus Photography in 1939 show the Horseheads Post Office being built on the corner of Main and Broad Streets. The house in the upper right corner was later moved to Fourth Street in order to build the Marine Midland Bank.

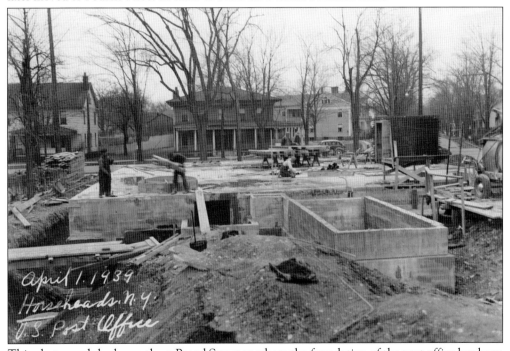

This photograph looks north up Broad Street to where the foundation of the post office has been laid. Samuel Plato was the contractor, and E. Dwyer was the construction engineer for the project. The Hungerford House is across the street on the corner.

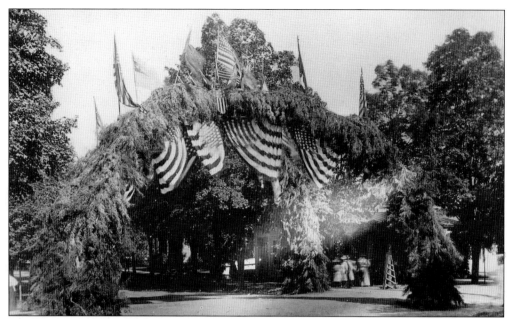

The house at 206 West Franklin Street, barely seen here through patriotic decorations, is possibly the oldest house in Horseheads. The Tifft family lived here in the early 1900s. Bela Tifft, a drayman, had a freight service, meeting trains with his horse teams and delivering goods to area businesses. In this early-1900 photograph, the house stands just past the ornate arch that served as an entryway to a celebration in Hanover Square. The house still stands, next to Pudgie's Pizza.

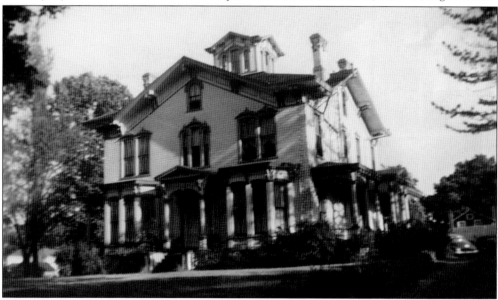

The 1860 Rice family farm stretched between Grand Central Avenue and Pine, Sayre, and Fletcher Streets, and featured barns and a racetrack on its grounds. Eugene "Zim" Zimmerman and his wife, Mabel Beard Zimmerman, lived in a portion of the home while building their house on Pine Street. The Schrage family purchased the home in the 1940s, and converted it into four additional apartments. Known for its many apartments, the building, seen here in 1946, received the nickname the Beehive. Now at 203 Fletcher Street, it is in the process of renovation.

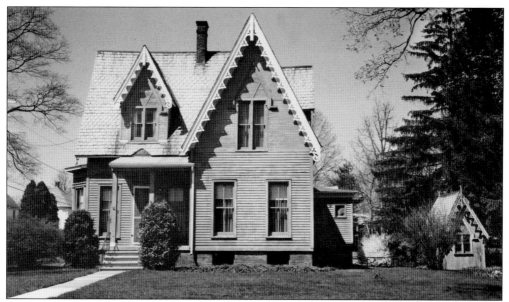

Dating from the Civil War era, the Dean home, at 606 Pine Street, was owned by Dr. George Dean, who shared a dental office with his brother Sam over Hibbard's Hardware on Hanover Square. In the back, the basement was exposed at ground level and housed the everyday kitchen and dining room, while the upstairs was used for formal entertaining. The Gothic Revival–style house had a matching privy (seen on the right in this 2001 photograph), which according to Nadine Ferraioli was the "only privy in town with wallpapered walls."

Charles Hulett was a major landholder south of the early village. This farmhouse was built in 1850 on his large plot of land. Hulett was a charter member of the Horseheads Building Association in 1854, which financed the construction of Hanover Square. In 1923, the back half of this house was moved 100 yards west. The address of the house today is 816 South Avenue.

A four-year-old Walter Myers poses in front of his family's home in 1891. The house, at 2227 Grand Central Avenue, was built in 1880–1881 by Richard Myers. The north side was added in 1902 by Thryza and Abram Myers. Nadine Ferraioli, Walter Myers's daughter, was an outstanding local historian famous for her Bygone Days articles in the *Chemung Valley Reporter*.

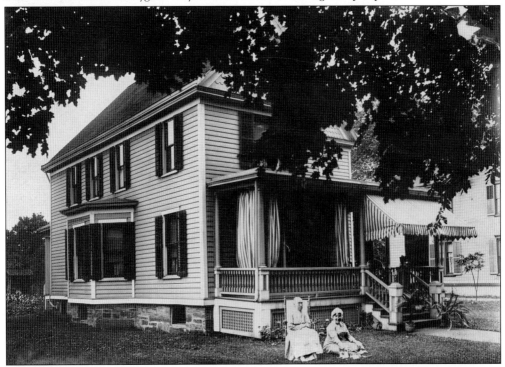

Across the street from the Myers house, this home at 2228 Grand Central Avenue was built in 1907. Here, on July 25, 1916, Nellie Owen and her mother take in a summer day.

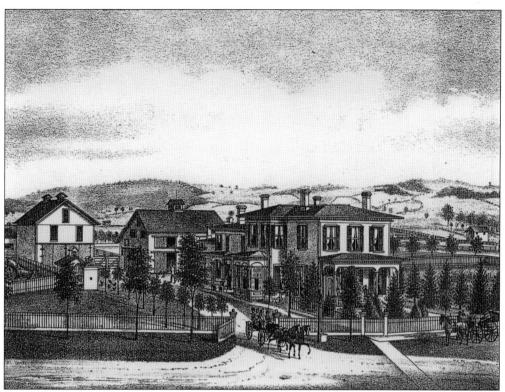

Seen in this mid-1800s lithograph, the John Livesay farm covered 70 acres. It was built by Livesay and his wife, Sally Bennett Livesay, around 1866. In 1918, the large Italianate house was divided in half. The original half of the house is known as the Boorom Place.

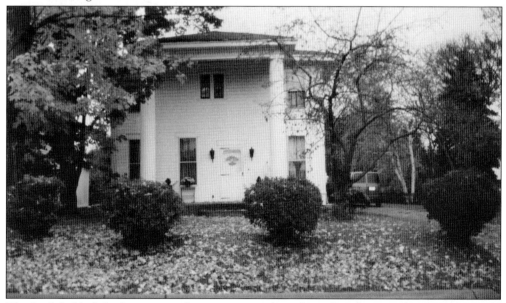

The back half of the house, seen here, was moved south to the adjoining lot. Greek Revival columns were added to the front porch, copied from the 1830 brick house in Millport, which had four columns and is seen on page 22.

Capt. Lewis S. VanDuzer, a graduate of the Naval Academy, was present at the Battle of Santiago, Cuba, in 1898 aboard the USS *Iowa*. His family home was on West Broad Street just north of the Pennsylvania Railroad station. The Bentley-Trumble Post of the American Legion occupied this home from 1946 until 2002. In this photograph, an addition is being built to expand the Legion. It was torn down in 2002 to make way for the new Lynch Funeral Home.

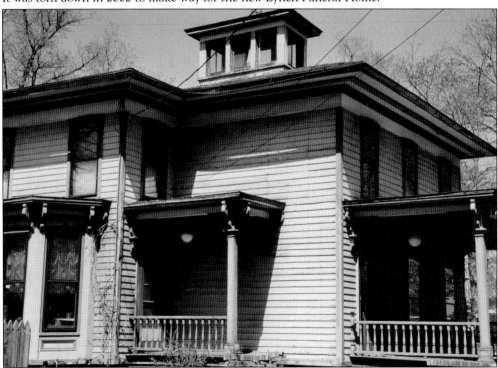

The Thomas Hibbard House, next to Teal Park at 506 South Main Street, was built before the Civil War. It is an excellent example of the Italianate style of the Teal park neighborhood. Thomas Hibbard came to Horseheads as a tinsmith and founded Hibbards Hardware in Hanover Square. After his death, his son Ralph and his wife, Maude Judson Hibbard, moved into the house.

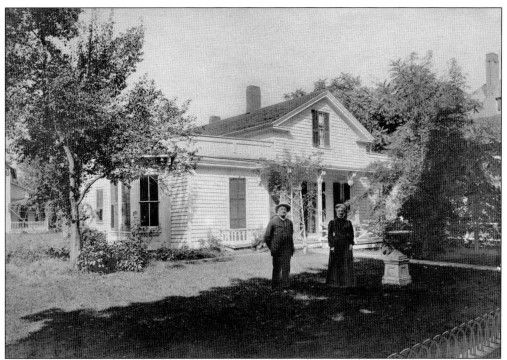

Peter Whitaker and his wife, Harriet, stand in front of their house, at 210 South Main Street. The house was the only wooden structure to withstand the 1862 Hanover Square fire.

This photograph, looking northwest towards Main and Steuben Streets, shows the Fred Bentley residence, which became and still is Barber's Funeral Home. St. Mathew's Church and Teal Park are across the street. The lot in the foreground has been cleared in order to build the new Horseheads Library. The Almah Bentley Brown residence had previously been at this site.

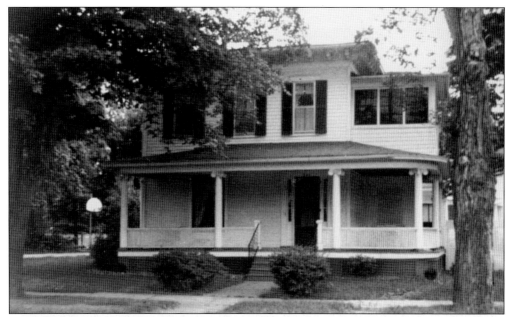

This Victorian home was built around 1870 for Mr. and Mrs. James McConnell. It is located at 501 South Main Street, across from Teal Park. It was later owned by Walter Daily, the Chemung County district attorney. After that, it was owned by the Charles Kinley family, who operated a tannery and brickyard in Breesport and a feed mill in Horseheads. The home remains a shining example of the Victorian era, with its exterior restored to original Victorian colors.

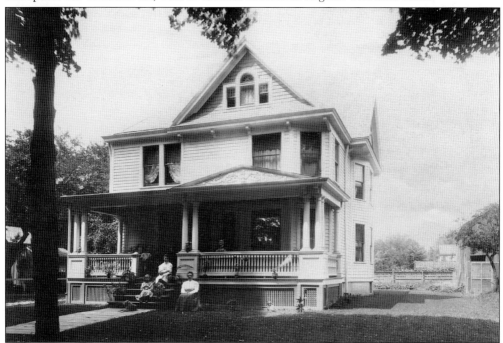

Vincent Conkling, one of the first settlers, acquired a large parcel in 1791 via the Soldier's Claim Act. This home, at 510 Pine Street, was built on the Conkling plot in the late 1800s. It is another beautiful example of Victorian architecture in the Teal Park neighborhood.

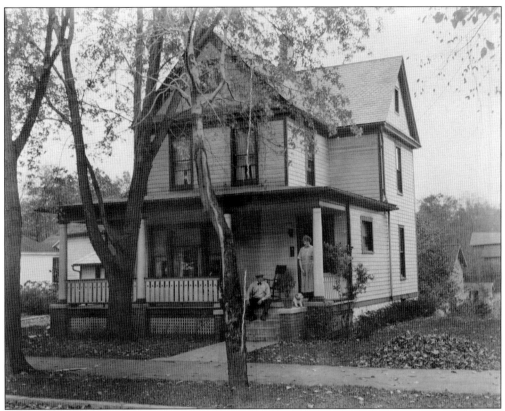

Lauren Thomas and his wife, Mary Messing Thomas, are seen here in front of their house, at 505 Grand Central Avenue (now 2270). Thomas was the co-owner of Thomas and Messing's store.

The intersection of North Main and Westlake Streets is seen here before the buildings on the east side were torn down in the 1930s. On the far right is the location of the village fire station.

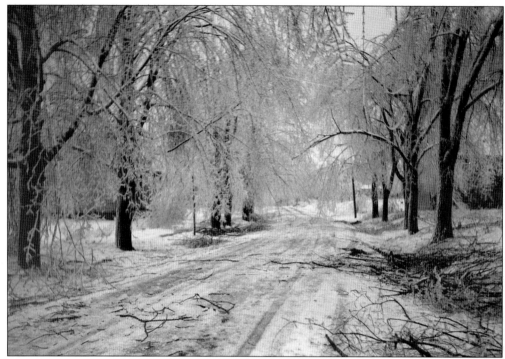

Branches bent by ice cover the road in front of 538 Westlake Street after an ice storm on March 18, 1936.

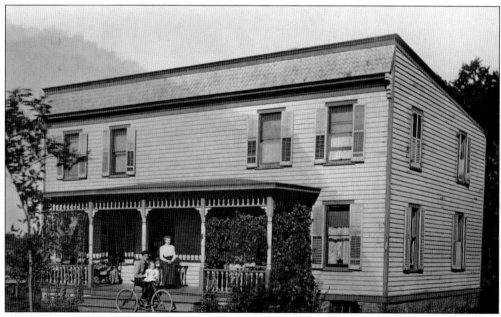

This home, at 601 Tuttle Avenue, was typical of company houses in the late 1800s and early 1900s.

This house, at 2244 Grand Central Avenue, was the first house in Horseheads to have electric lights. The official celebration of electricity in the village was held in 1904 at the Platt Hotel in Hanover Square.

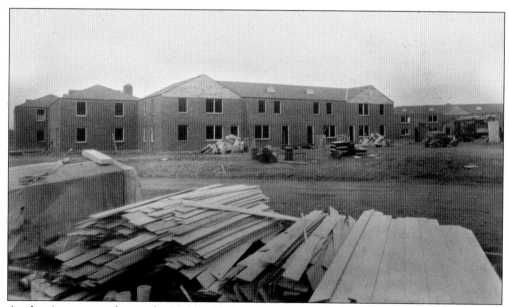

As the Army moved into the Holding Point and the population of Horseheads grew, it was necessary to increase available housing. The Victory Heights Apartments were built in 1944 by Salvatore Indelicato on Grand Central Avenue. At the same time, the Catalpa Drive subdivision area was developed.

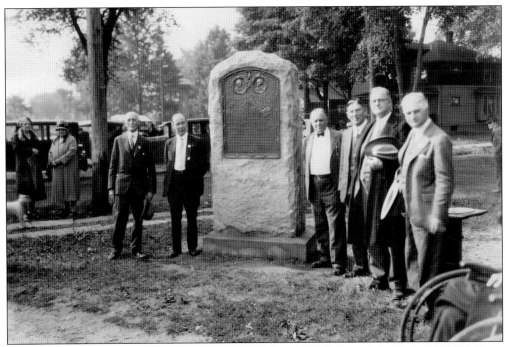

This monument, at Sayre and Main Streets, was dedicated to Sullivan's Campaign in 1929. From left to right are A.M. Wixon, unidentified, Mayor Oliver Eisenhart, Rev. T.J. Bolger, Harvey Hutchinson, and Ben "Atly" Levy.

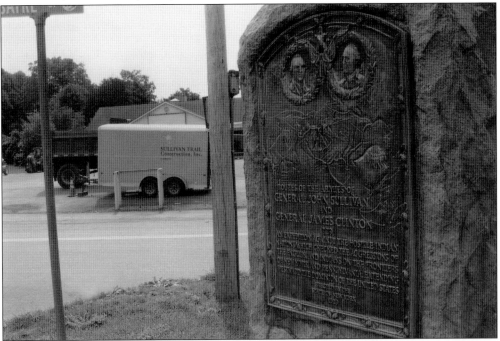

This is a recent photograph of the same monument. Notice the Sullivan Trail construction equipment, which belonged to a contractor working in the same area that was Sullivan's trail in 1779. (Photograph by Marcia Tinker.)

Six
SOCIAL LIFE

Although not the county seat, Horseheads was the social and political center for Chemung County. Many fairs, social gatherings, political conventions, and sporting events were held in and around Hanover Square. The abundant hotels and saloons offered hospitality to all. Pritchard Hall, on the second floor over Hibbard's Hardware, was a large gymnasium-sized hall that adapted to fairs, dances, and even basketball games.

Many civic, social, and fraternal organizations preserved small-town traditions. Organizations that grew along with the village were the Bentley-Trumble Post of the American Legion, the Masons and the Order of the Eastern Star, the Horseheads Women's Club, the Lions Club, the Rotary Club, the Grange, Elks, and Jaycees, to name a few.

Horseheads has always loved a parade, from the early firemen's conventions to Memorial Day and patriotic celebrations. The firemen's conventions were very elaborate in pomp and circumstance, with amazing decorations. Later, the Zim Band and the Zim Boys Bands were formed by Eugene "Zim" Zimmerman to entertain the citizens of Horseheads.

Before schools had organized team sports, local citizens and civic groups sponsored basketball and football teams. Basketball games were played in Pritchard Hall. For out-of-town games, the teams traveled to neighboring towns by train. In the early 1900s, school teams were organized.

Theater was performed by many groups. The Presbyterian choir presented musical farces, and there was a Shakespeare class that performed in costume. In the 1950s, the Horseheads Fire Department even put on minstrel shows.

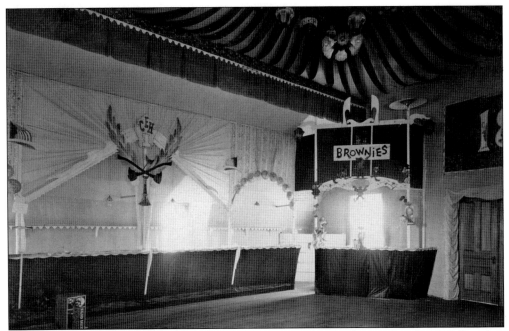

Many fairs, social hops, military balls, and sporting events took place in Pritchard Hall and in Hanover Square. Located over Hibbard's Hardware, the large theater/gymnasium/meetinghouse/dance hall was named for its original owner, Hiram Pritchard, who came from Corning. In this March 1923 photograph, the hall is decorated with Eugene "Zim" Zimmerman's characters for a firemen's event.

For another event, Zimmerman has created large cutouts and characters for a fair at Pritchard Hall. In his autobiography, Zimmerman writes, "I have been honored periodically with the decorating committee chairmanship of local fairs of firemen, Masons and Odd Fellows, each of which exacted two weeks of time and energy. There is a lot of glory attached to such activity, but it fades when the function ends."

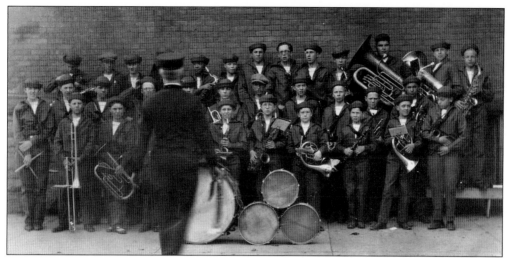

Zim's Boys Band was organized by Zimmerman for the Horseheads Civic and Commercial Club in the early 1900s. This large group of boys was given instruments and uniforms and taught music as part of Zim's musical project for the community.

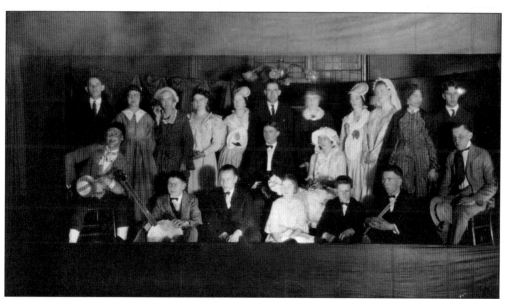

The Bean Town Choir, a musical farce by the Presbyterian church choir, was presented in March 1923 in the church parlors, and again in April on the stage at Pritchard Hall. The cast includes, from left to right, (first row) Thomas Treat, Kenneth Mosher, Mary VanDuzer, Paul Ostrander, and Stephen Hill; (seated, left) Ralph VanDuzer; (seated, center) Milton Roy and Marjorie Hamblin; (seated, right) Minor Jones; (standing) Earl Breon, Grace Breon, Edith Stokoe, Florence Hill, Bessie Nichols, Harry Sniffen, Mae Park VanDuzer, Harriet Nichols, Ruth Breon, Mary VanDuzer, and James Rodbourn. Missing for this performance was Estelle VanDuzer.

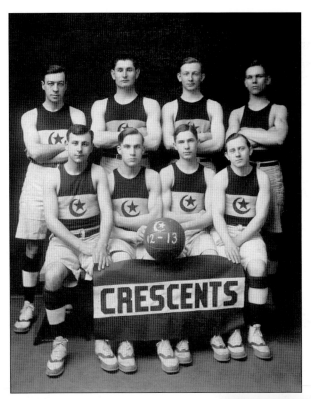

The Horseheads Crescents basketball team was supported by interested people and merchants. Pritchard Hall was set up for basketball in the early 1900s, and it was a very popular spectator sport at the time. The 1912–1913 team includes, from left to right, (first row) Roy Garrison, Edward Myers, John Heher, and Lawrence Hensdall; (second row) Porter B. Carpenter, Seymour Hollenbeck, Leroy Bogardus, and Lee Orminston.

Another basketball team in those days was the Brotherhood, an Irish team that includes Walter Rockwell (in front) and, from left to right, (first row) Matt Lynch, Jim Eddy, and Dick Eisenhart; (second row) Clifford Wheeler, Roy Martin, and Alden Seeley.

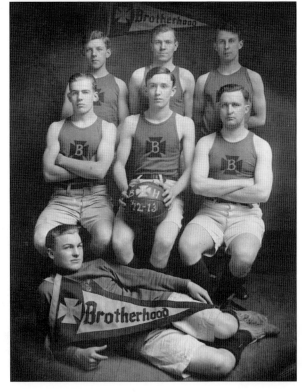

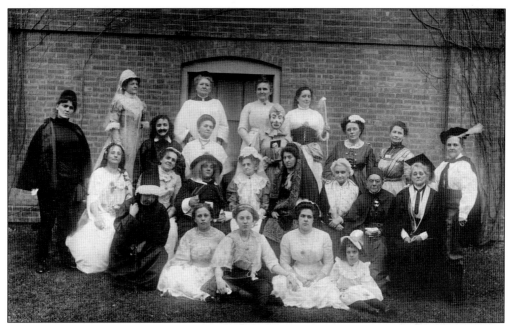

The 1910 Shakespeare class luncheon was held at a Mrs. Christian's home. Seen here posing in front of the Baptist church, the group includes, from left to right, (first row) Mattie Slayton, Ruth Christian, Katherine Wintermute, Georgia Weller, and Jeannette Wells; (second row) Mrs. Christian, Mrs. Weller, Mrs. Austin, Mrs. Row, Mrs. Wintermute, Mrs. Ricky, Mrs. Barber, and Mrs. Bowers; (third row) Mrs. Brooks, Mrs. Crane, Mrs. Turner, Mrs. Colwell, Mrs. Shappee, and Mrs. Hibbard; (fourth row) Mrs. Manning, Mrs. DeCamp, Mrs. Haines, Mrs. VanDuzer, and Mrs. Clark.

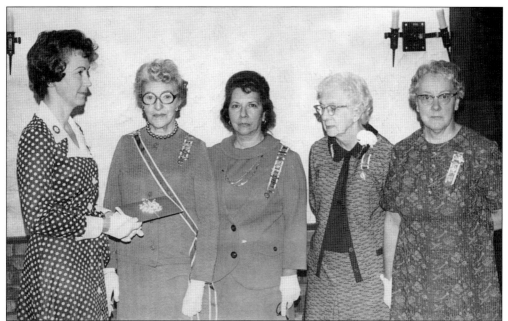

These members of the Daughters of the American Revolution, Horseheads, are, from left to right, Jan Rohr, unidentified, Ruth Shipman, Edith Carpenter, and unidentified.

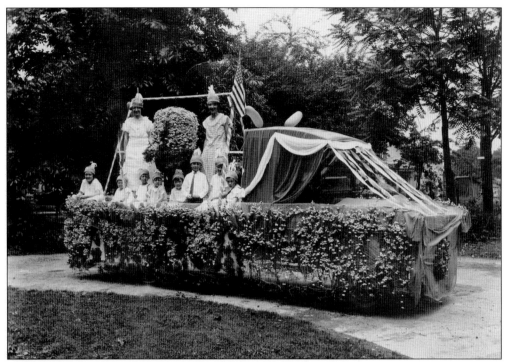

Children of the Alta Club ride on a parade float in 1924. Horseheads has always been known for its fabulous parades. Here, from left to right, are (sitting) VanDuzer girl, A. Jones, Frances Mary Egbert, Mary Frances Barber, Marian Green, Richard VanWhy, Ann or Virginia Jones, and unidentified; (standing) Lucy VanDuzer and Mrs. Barnes.

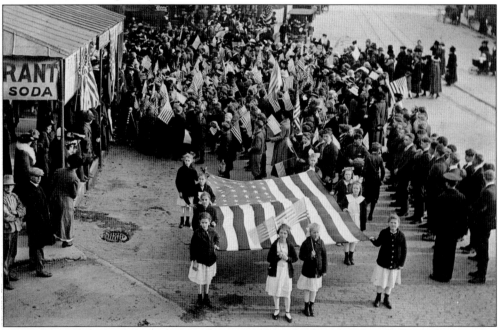

This Memorial Day parade is ready to begin, as schoolchildren stand with the American flag. Horseheads continues to have the longest Memorial Day parade in the area.

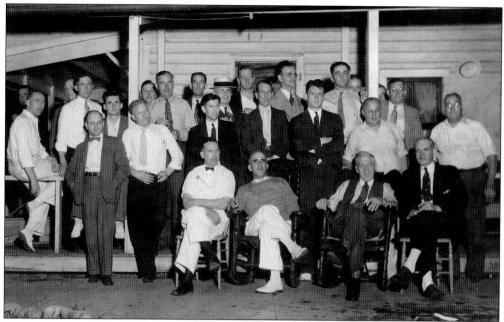

Friends of O.D. "Ollie" Eisenhart got together at his Himrod cottage on Seneca Lake in the 1930s. Seen here are, from left to right, (first row) Mott Westlake; Ralph Hibbard of Hibbard's Hardware; Henry Messing of Messing's Men's Store; and Bill Wightman, barber; (second row) Louie Sayres of Sayres' Meat Market; Dorn Palmer, barber; Roy Martin of Winchester Optical; Fritz Otis; Tom Patrick Lynch of Winchester Optical; Ollie Eisenhart, mayor; Burt Bush; and Ducky Drake; (third row) Henry Johnson; Harry Gustin; Lew Whitaker; Leo Walker; Fran Lynch; Harry Kahler; Art Magee; John St. John; Howard Fox; Dorn Dilmore; Ted Hollenbeck; Henry Tucker; Ford Einbeck; Mark Tabar; and Bill Whitman.

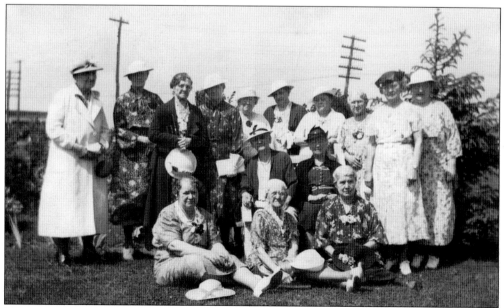

Mrs. Maun entertained the Linden Sunshine Circle at Charles Sterupple's home on a summer's day in 1935.

Another popular club for ladies was the embroidery club. Seen here in 1937 are members, from left to right, (first row) Daisie C. VanNane, Elmira Hibbard, and Sara Dykes; (second row) Amy Parks, Florence Shappee, Winifred Keiffer, Lena Bogardus, and Clara Jansen. Mrs. Mort Rickey was absent on this day.

Methodist church ladies pose in front of the church in 1938. They are, in no particular order, Mrs. Bogardus, Jessie Oldroyd, Venie Park, Mrs. George Curns, Mrs. White, Mrs. Cook, Mrs. Willett, Mrs. Wright, Mrs. Jacobs, Bertha Youmans, Mrs. Lewis, Mrs. Smyros, Mrs. Isabel, Charlotte Lawler, Miss Styres, Mrs. Millspaugh, Carrie Carrier, Mrs. Stevens, Mrs. Dolph, Mrs. McQueen, Mrs. Ball, Mrs. Bowman, Mrs. Peterson, Mattie Southard, Nettie Hauson, and Mrs. Lawhead.

Social activities were held at the newly built modern hall of the Horseheads Grange No. 118. This youth group posing in 1941 includes, in no particular order, Lloyd Shappee, Louise Howell Scott, Dudly Updyke, Nancy Wigsten Baker, Margaret Stermer, Jim Douglas, Robert Howell, Harry McCann, and Hugh Douglas.

Seen here around 1940 are state Grange officers, from left to right, Leon VanGorder, Morris Hallady, William Stedge, and Albert B. Howell.

The Social Club was a group of local businessmen in the early 1900s. The club includes, from left to right, (first row) Henry Messing, Ward Kinley, and Harry Burris; (second row) James Walsh, Rufus Platt, Dan Hibbard, Fayette VanOrden, and Lauren Thomas; (third row) Earl Kimble, Jesse Peck, Bill Wightman, C.L. Judson, and Charles Goodyear.

This 1940 Horseheads bowling team includes businessmen, from left to right, Steve Popp of the *Chemung Valley Reporter*; Marion Jansen, electrician; Kenneth Campbell, insurance and gas station owner; Louis Garlick, road machinery; Dorn Dilmore, barber; Dewitt Dilmore, barber; and Jack Kennon.

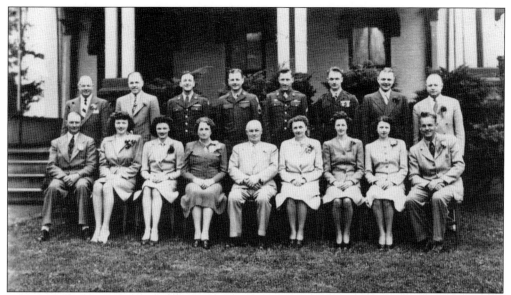

On Mother's Day, May 12, 1946, the Eisenhart family returned to the family's former home, which had become the Crystal Manor Restaurant. The family includes, from left to right, (first row) Bennett, Dortha, Betty, Louise (mother), Oliver D. (father), Myrtle, Josephine, Alice, and Ford; (second row) Gilbert, Franklin, Mark, Joe, Judson, Edward, William, and Ollie Jr. Richard was not present.

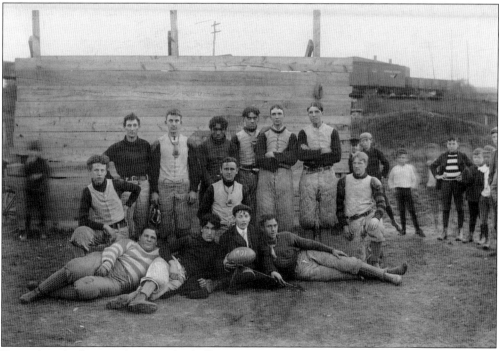

Young boys look on as this 1901 football team poses for a team photograph. The team includes, from left to right, (lying down) unidentified, Rufus Platt, mascot Henry Bush, and Al Perry; (kneeling) George Andrews, Alton Genung, and Harley Pierce; (standing) Fred Wenk, William Wintermute, 'Lish Swan, Art Magee, Bob Perry, and Bob Smith.

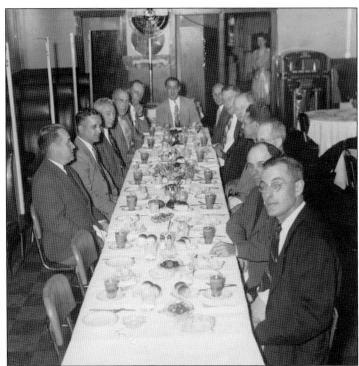

Horseheads Masonic Lodge No. 364 is seen here enjoying a dinner for past masters at the Tasty Shop in the early 1950s. From left to right are John Rowles, Pete Woloson, Jim Donahue, Harry Hammond, unidentified, Dr. ? Mosel, Henry Edger, Ed Dykes, Clyde Paul, George Baer, Ed Billings, Carlton Gregory, and Rowland Jacobus. The lodge was chartered in 1855.

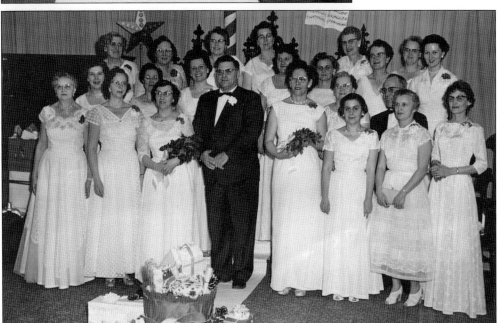

The Order of the Eastern Star Chapter 432 was founded in 1908. Seen here on January 11, 1960, are members, from left to right, (first row) Minnie St. John, June Shopes, Sara Howland (matron), Jack Howland (patron), Laura Hall, Vera Close, Eleanor Long, and Marie Wintermute; (second row) Harriet Edger, Dorothy Bennett, Ruth Allen, Betty Mosher, Peggy Bower, unidentified, Thelma Baker, Francis Trumbell, and unidentified; (third row) June Whitaker, Eloise Blodgett, Vaneda Trumbell, Ruth Cook, unidentified, and Jean Clark.

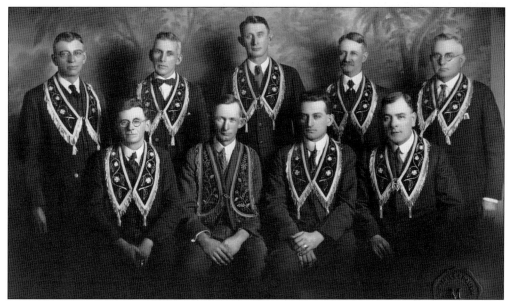

The Chemung Valley Odd Fellows Lodge No. 419 met on the third floor of its building, on John Street. Seen here in 1921 are, from left to right, (front row) Charley Rickey, Clinton Swain, Harry McDonald, and James Wheat; (second row) Earl Shultz, Ray Sterling, Frank Jackson, S.B. Cohen, and Edward Sayre.

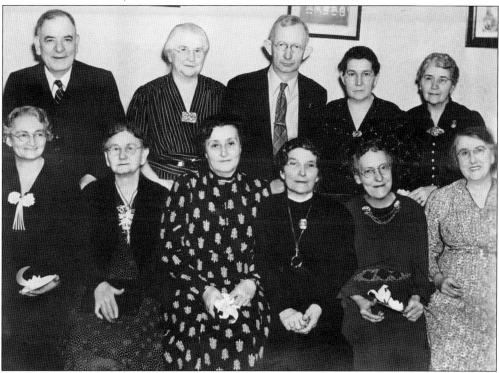

The Rebekahs and Odd Fellows are seen here in the mid-1920s. They are, from left to right, (first row) Anna Shultz, Flora Benjamin, Clara Jansen, unidentified, Minnie Corel, and unidentified; (second row) Sam Cohen, Catherine Wigstein, Earl Shultz, Joan Shultz, and Winifred Tifft Keefer.

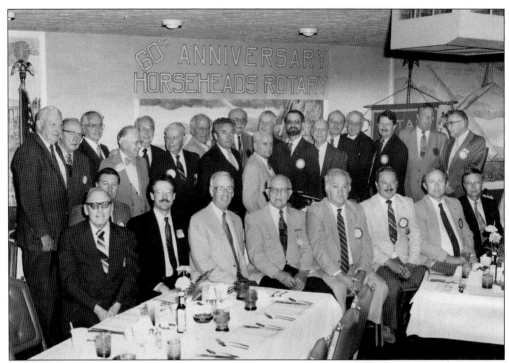
The Horseheads Rotary Club is seen here celebrating its 60th anniversary with a banquet.

The Lions Club began in 1952 with 41 charter members and Charles Goodyear as the first president. This 1969 group includes, from left to right, (first row) George VanKirk, Gerry Laughlin, John Palmer, and Keith MacIntosh; (second row) unidentified, Bob Owens, Rudy Baer, Tom Banfield, and Allen Falts.

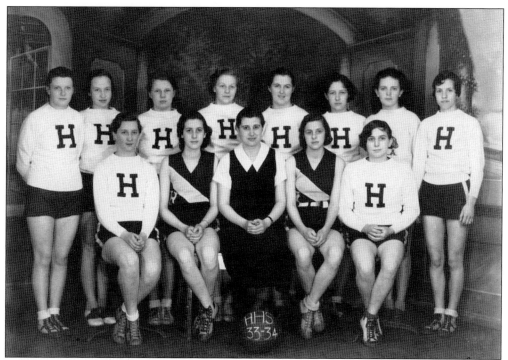

School sports played an important role in the social life of the community. The 1933–1934 Horseheads High School girls' basketball team photograph includes, from left to right, (first row) Elizabeth Day, Irene Doud, coach Jeanette Mills, unidentified, and Peg Rodabaugh; (second row) unidentified, Liz Campbell Tifft, Ann Jones Reubens, Betty Myers Schoenhafer, Cath Murphy, Betty Bush Ray, Jean Shanley, and Mary Mon Blodgett.

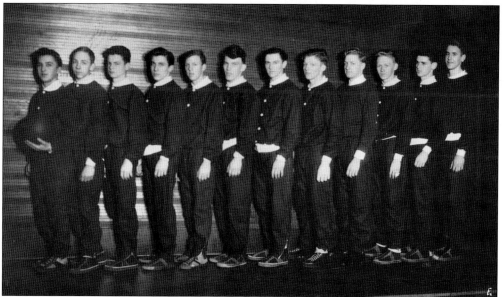

The 1935 Horseheads High School boys' basketball team includes, from left to right, Mark Goodyear, Jack Campbell, Jim Lynch, Burt Travers, Ed Willett, Herb Freeland, Bob Tompkins, Al Edwards, Jud Eisenhart, Dick Myers, Everett Stansfield, and Jim Wheaton.

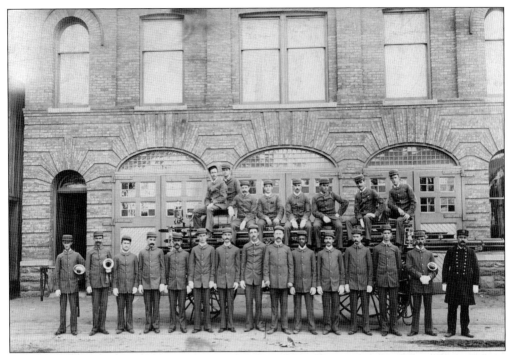

Fire departments have always played an important role in the community. When there was not a fire, there was always an event or fundraiser to put on. Horseheads in the early 1900s was a mecca for fire conventions. This 1900 fire battalion poses in front of the new fire station and town hall at Main and John Streets.

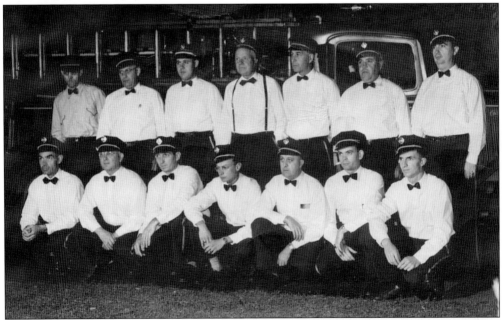

Members of the Chemung County Fire Department stand in front of one of their trucks. Horseheads firefighter Ray C. Margeson is third from the left in the top row. (Courtesy of Richard Margeson.)

The Horseheads Fire Auxiliary was formed in 1940. This photograph was taken at a state convention in Albany. The "kitchen band," as they were known, includes, from left to right, (first row) Marion Kreisler, Karen Margeson, Maria Margeson, and unidentified; (second row) Barb Tighe, Ginnie Coon, Mildred Cook, unidentified, Fern Lynch, and Eloise Councilman. (Courtesy of the Tighe family.)

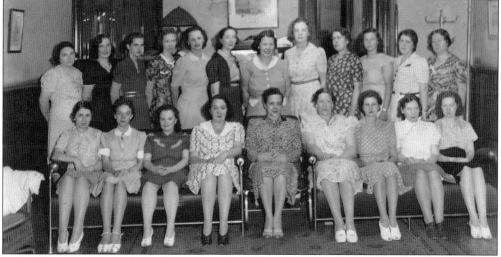

The Ladies Auxiliary of the Horseheads Fire Department was formed in 1940. The founding members are, from left to right, (first row) Alice Mallory Youmans, Florence Waseck, Mrs. James Baldwin, unidentified, Barbara Margeson, Fern Lynch, Alice Whiting Jeffrey, Nellie Barr Bowers, and Edna Hamilton Phillips; (second row) Florence Hamilton Kimble, Leona Phillips, Margaret Westlake, Naomi Hamilton Carson, Doris Baer, Peggy Austin, Kathryn Bowers Shafer, Eloise Councilman, Mary Curns, Thelma Miller Hamilton, Helen Spencer Brown, and Marie Swartwood.

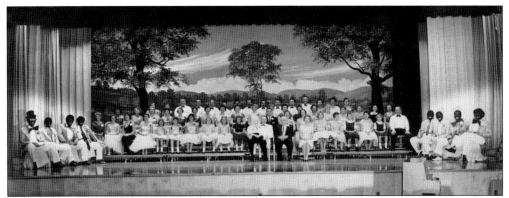

In the 1950s, the Horseheads Fire Department presented annual minstrel shows on the high school stage. The players in the March 1955 minstrel show are, in no particular order, Robert Fisher, Joe Lawlor, Leon Grual, Frank Goodyear, George Baer, Jerry Curns, Bud Curns, Phil Scott, Marjorie Grant, Sue Grubb, Ardith Gunderman, Sandra Margeson, Linda Lawlor, Mimi Hodge, Robert Travers, Bill Whedon, Loren Wood, Dick Curns, Rudy Baer, Helen Reynolds, Gwen Crofutt, Sally Kambeitz, Danielle Rodabaugh, Mrs. Gilkerson, Nancy Goodyear, Don Brown, Don Blide, Kenneth Borden, Joe Folk, Robert Welch, and Harold Bennett.

This 1962 parade celebrates Horseheads' "triple centennial"—Eugene "Zim" Zimmerman's birthday and the 100-year anniversaries of the 1862 fire and the Civil War. In 1962, the Chemung Canal Bank's branch office opened, local government employees moved into the new village hall, and the Grand Central Plaza was one year old.

The Horseheads Historical Society was known for its antique shows in the 1980s. Here, at the September 1986 antique show, the unidentified trolley driver (left), Nadine Ferraioli (center), and Tina Williams wait for passengers.

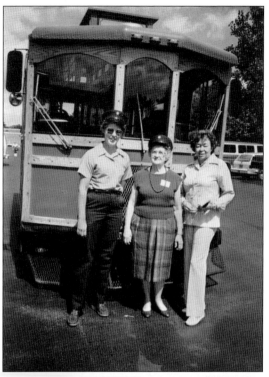

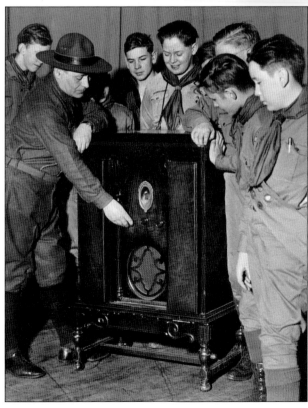

Boy Scout Troop No. 44, seen here with Scoutmaster B. Calkins, admires a modern radio.

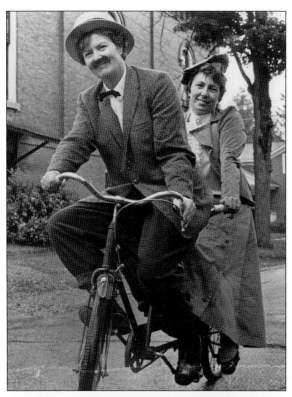

Sylvia Cole (back) and Priscella Read don costumes and ride a tandem bicycle for the 1979 bicentennial celebration parade.

This bicentennial parade float celebrates the Horseheads Women's Club's role in starting the Ruth B. Leet Library. On the float are Carolyn VanDuzer (left), Rudy Baer (center), and Jerry Backer.

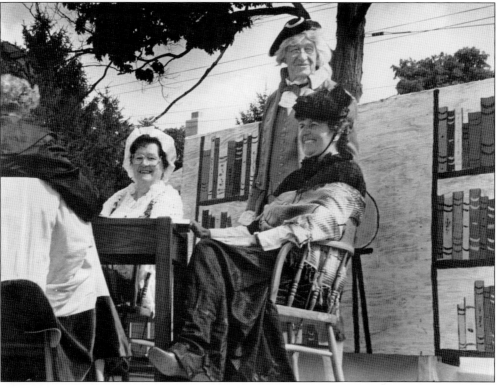

Seven
HORSEHEADS PEOPLE OF NOTE

Horseheads has had many exceptional citizens throughout its history, all the way up to today. Many of them have been mentioned in prior chapters. This chapter is dedicated to all of the men and women who have made Horseheads what it is today.

Franklin L. Fisher was born in Horseheads on August 24, 1885. He began his photography career in 1907 in New York City as a writer and photographer. He joined the staff of *National Geographic* magazine in 1915. During his term, the National Geographic Society's library of images of people, places, natural history, and events grew in scope. Fisher maintained a summer residence on Main Street. He died in 1953, and in his generosity, endowed the establishment of a community museum. Two paintings by N.C. Wyeth, artwork, sketches, a book collection, and a complete set of *National Geographic* magazines were inherited by the Horseheads community.

Brig. Gen. Orman Goodyear Charles was born on Ridge Road in Horseheads on April 14, 1908. He was a graduate of Horseheads High School and Cornell University. General Charles's military career spanned from World War II through the 1960s. In 1959, he was promoted to brigadier general and was named the duty chief of the US Army Security Agency, a post he kept until his retirement from active service in 1963.

Known as one of the country's foremost political cartoonists, Eugene "Zim" Zimmerman was born in Basel, Switzerland, in 1862. Due to the instability of Europe, he was sent to join his father in Paterson, New Jersey. At a very young age, he became an apprentice sign-maker and moved to Chemung County. When not painting signs, Zim began to sketch and develop his creative talents. While he was visiting New York City, Zim's talent was discovered by Joseph Keppler of the comic weekly *Puck*. In 1885, Zim joined the *Judge* magazine, remaining there until 1930. Zim was the founder of the American Association of Cartoonists and Caricaturists. He made Horseheads his permanent home, his house is now a museum, and his bandstand graces Teal Park.

Franklin Fisher was born in this farmhouse on East Franklin Street in 1885. He began his photographic career in 1907. In 1915, he joined the staff of *National Geographic* magazine and became a force behind the development of color photography in the magazine.

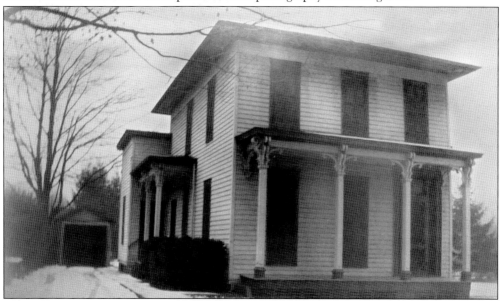

Fisher and his wife, Ami Dimond Franklin, were married in 1910. They maintained a permanent summer residence at 906 South Main Street. Mr. Fisher was a member of the Elmira City Club, the Elmira Country Club, and was active in local philanthropic and civic endeavors.

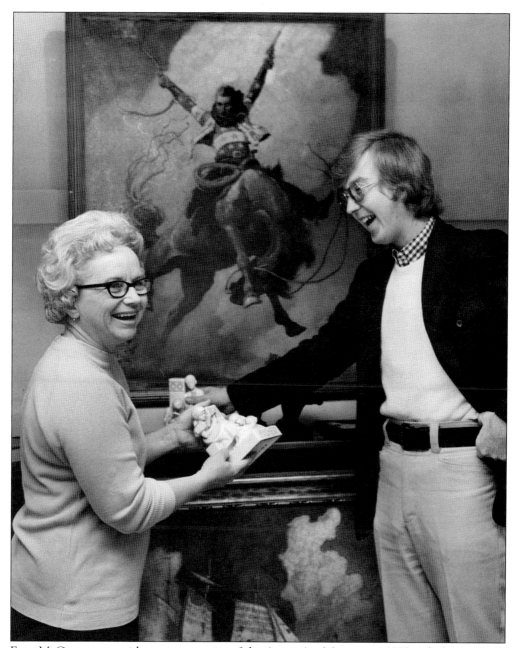
Ester McCann poses with a representative of the Arnot Art Museum in 1975 with the two N.C. Wyeth paintings that were given to the citizens of Horseheads by Franklin Fisher. The paintings are now on loan to local museums. *Bronco Rider* is at the Rockwell Museum in Corning, and *The Conquerer* is at the Arnot Art Museum in Elmira.

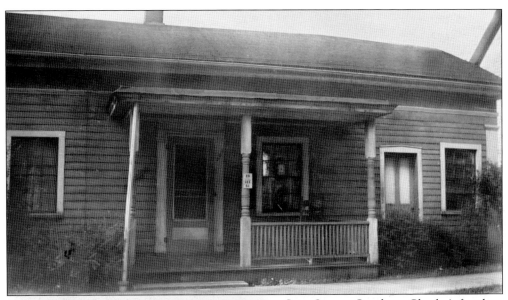

Gen. Orman Goodyear Charles's family home was on Broad Street next to the current Baptist church. He was a lifetime member of American Legion Post No. 442, Horseheads Masonic Lodge No. 364, and Horseheads Presbyterian Church.

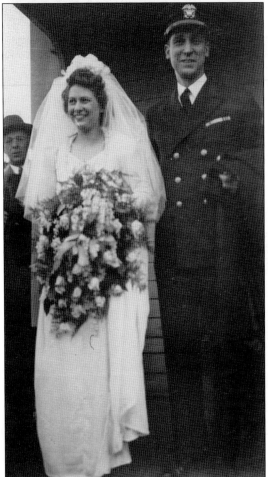

General Charles and bride, Elizabeth Deahl Charles, are seen here on their wedding day. Mrs. Charles was a graduate of the Army School of Nursing at Walter Reed Army Hospital in Washington, DC. She also served her country for several years as an officer in the Army Nurse Corps, at West Point, at Fort McPherson, Georgia, and overseas in the Philippines.

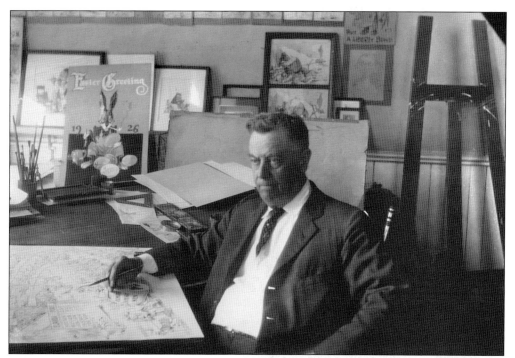

Eugene "Zim" Zimmerman worked for *Puck* and the *Judge* magazines, created a correspondence course, and wrote many books. He twisted and rewrote local history in *The Foolish History of Horseheads*, *The Foolish History of Elmira and Its Tributaries*, and *In Dairyland*. In this 1926 photograph, Zim works in his studio overlooking Hanover Square.

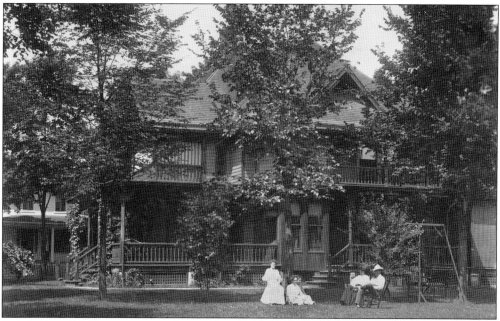

Zim designed his home at 601 Pine Street, and built it with the help of his father-in-law, Alvah P. Beard, a master carpenter, in 1890. The home was given to the historical society by his daughter Laura upon her death. His artifacts, artwork, and collections are on display.

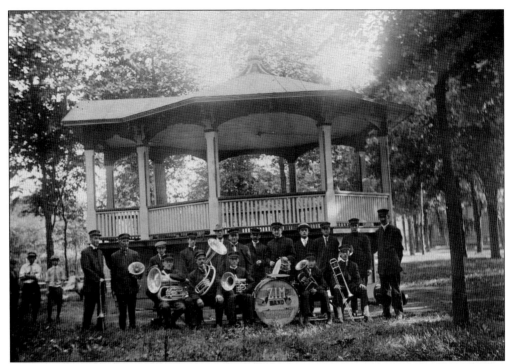

Zimmerman's love for music and merriment created the formation of the Zim Band in the late 1880s. He could not play an instrument himself, but chose instead to organize and support local musicians. His band of 30 players lasted until World War I.

This caricature of the band appears in Zimmerman's *Foolish History of Horseheads*. In his book, he comments, "The band is a great acquisition to our town. You bet, it puts ginger in us, causes us to step lively and sets our patriotic blood to coursing. So if you love music you can find it at least one night a week in Teal Park. Come up and shake hands with your rube cousins."

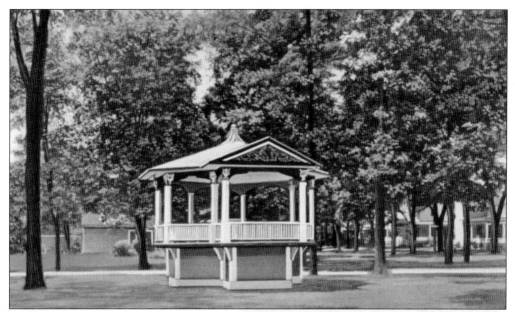

Teal Park, the home of the Teal schoolhouse, was one block from the Zimmerman home. His band needed a place to play, so Zim designed and built the bandstand seen above in Teal Park. Two crickets and a frog playing musical instruments, carved by Zimmerman, festoon the frieze of the bandstand. It has been refurbished, repaired, and repainted over the years. Summer concerts are still offered, as he said, "at least one night a week."

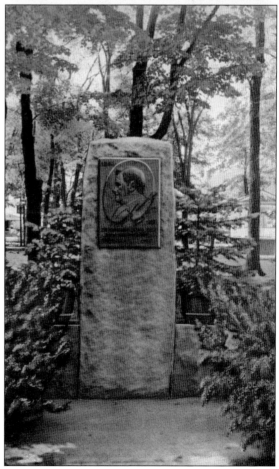

In 1939, a granite monument was erected to commemorate Zimmerman's contributions to the community. The bronze plaque reads, "In Memory of a Great Artist, Eugene Zimmerman."

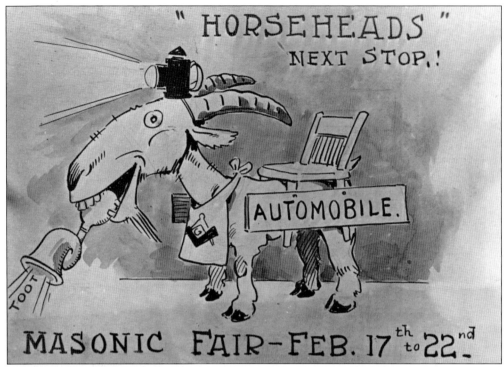

Zimmerman joined local organizations and was at their beck and call for advertisements and decorations for events. He often decorated Pritchard Hall and created posters and handbills for the fire department, the Masons, and the Odd Fellows. This postcard announces the 1908 Masonic fair.

This scene not only illustrates Zimmerman's thoughts on George Washington's birthday; it also gives an indication of how prolific and imaginative he was. This is just one example of his humor and portrayal of mankind.

Zimmerman wrote the *Doings of the Dingville Fire Department* for the American LaFrance Manufacturing Company's newsletter, the *Alfco Stream*. American LaFrance, in neighboring Elmira, was one of the pioneers of fire apparatus manufacturing. In this cartoon, Zimmerman depicts "First Aid Combination–Hooks & Chemical of Dingville." This was perhaps his idea of early emergency medical technicians.

Zim had many very close friends in the Horseheads community. Below, in the late 1890s, he and his cronies pose in a photographer's studio. Zimmerman is second from the right in the first row, and others are identified as T.J. Wintermute (1), Dr. LaRue Colegrove (2), and John Barlow (3).

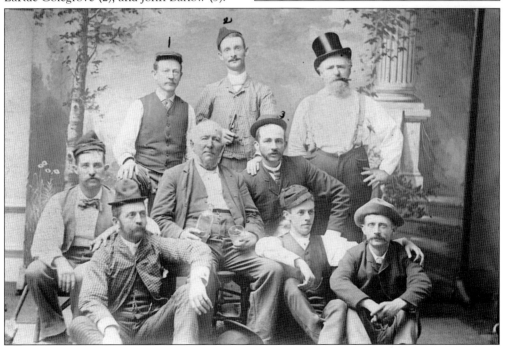

Laura Zimmerman and her mother, Mabel Beard Zimmerman, stand in the side yard of their Pine Street home. Laura was Eugene "Zim" Zimmerman's only child, and upon her death in 1980, she willed the Zimmerman estate to the Horseheads Historical Society. She had preserved all of her father's original artwork, writings, notes, clippings, memorabilia, and possessions, leaving them in trust for their further preservation. Zim House is now a museum and is open to the public upon request.

Laura Zimmerman also enjoyed her father's spirit for a good time. They are seen below posing in costume at an 1893 Horseheads fair. Zimmerman is in back wearing the black beard. The others are, from left to right, (lying down) Nellie Ludlow and May Zimmerman; (sitting) Josephine Matien, a very young Laura Zimmerman, and Ada Beard.

In the entrance of Zimmerman's Pine Street home, he designed his name in the inlaid wooden floor. His home was restored to its original Victorian color, and wallpapers have been reproduced to their original patterns. A great room with a two-story ceiling and overlooking balcony is adorned with his collections.

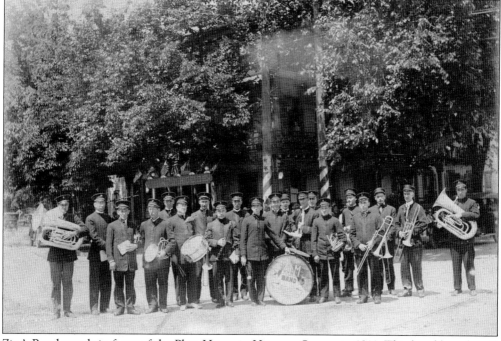

Zim's Band stands in front of the Platt House in Hanover Square in 1911. This band lasted until the onset of World War I.

John Bennett, seen here around 1930, was the president of the Horseheads First National Bank and the onetime owner of the brickyard. His daughter, Louise, married O.D. "Ollie" Eisenhart.

This group of prominent citizens enjoys an outing at nearby Rorick's Glen. John Bennett is on the far left, and third from the left is Dr. Robert Bush, a member of the New York State Assembly.

Harriet and Bessie Nichols are well-known Horseheads historians, as they documented everything that they ever did. Their huge collection of scrapbooks cover every topic and are in the archives of the historical society. Harriet was also an artist and a stamp collector who created one-of-a-kind thematic postage stamps and art pages.

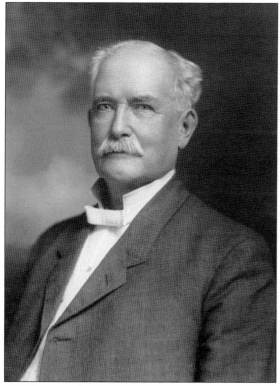

Capt. Lewis S. VanDuzer was an 1876 graduate of the Naval Academy and was present at the Battle of Santiago, Cuba, in 1898. His family home, on West Broad Street, later became the American Legion and was razed in 2002 and replaced by the new Lynch's Funeral Home.

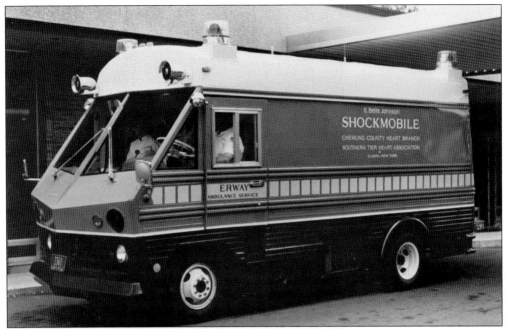

E. Belle Johnson was known for her extensive philanthropy in the mid-1900s. The Horseheads Library was organized by the Women's Club in 1944, and a new library building was dedicated in 1969. The new building was principally financed by a large bequest from Johnson, who was also responsible for the purchase of the first Shockmobile in Chemung County, seen here in the early 1960s.

Talitha Botsford is known for her watercolors of Chemung County landmarks. Her family home was in Sullivanville, on the edge of Horseheads. In this 1960s postcard, Botsford depicts the new village hall and fire station, Eugene "Zim" Zimmerman's house and bandstand, and Brown's Pharmacy. Many of Botsford's paintings can be seen at the Horseheads Historical Museum.

John Bogardus was the photographer of Horseheads in the early 1900s. His studio was just off Hanover Square, on Ithaca Road. Later, he moved to the upstairs of the Mosher block, in the square. Many residents and civic groups posed for his cameras as he documented the events of the era. Unfortunately, many of his photographs are now gone. In this portrait, the photographer himself poses with son Ritchie, who died at the young age of six.

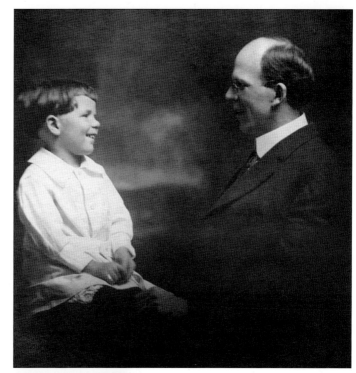

Horseheads' beloved late historian Nadine Ferraioli is seen here playing conductor for the antique show trolley in September 1986. This book would not be possible without the notes, boxes of information, and writings of Nadine Ferraioli and Paddy Bachman. They are both missed.

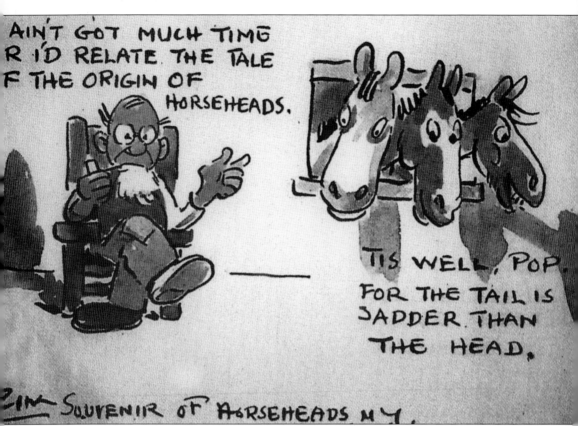

Eugene "Zim" Zimmerman sums it all up in his 1911 *Foolish History of Horseheads*, in which he writes, "Don't know what'd become of us if they'd found a pile of horse tails instead."

About the Horseheads Historical Museum

For more information, please visit the Horseheads Historical Museum, which is open Tuesday, Thursday, and Saturday, April through December, from 12:00 p.m. to 3:00 p.m. Zim House is open for tours upon request.

Horseheads Historical Museum
312 West Broad Street
Horseheads, New York
(607) 739-3938
www.horseheadshistorical.com

Discover Thousands of Local History Books
Featuring Millions of Vintage Images

Arcadia Publishing, the leading local history publisher in the United States, is committed to making history accessible and meaningful through publishing books that celebrate and preserve the heritage of America's people and places.

Find more books like this at
www.arcadiapublishing.com

Search for your hometown history, your old stomping grounds, and even your favorite sports team.

Consistent with our mission to preserve history on a local level, this book was printed in South Carolina on American-made paper and manufactured entirely in the United States. Products carrying the accredited Forest Stewardship Council (FSC) label are printed on 100 percent FSC-certified paper.